MURDER & MAYHEM
— IN —
CENTRAL
MASSACHUSETTS

MURDER & MAYHEM
IN
CENTRAL
MASSACHUSETTS

RACHEL FAUGNO

THE
History
PRESS

Published by The History Press
Charleston, SC
www.historypress.net

Front cover image of Main Street, Worcester, from LeBeau-Morrill Bullard Collection.

First published 2016

Manufactured in the United States

ISBN 978.1.46711.927.6

Library of Congress Control Number: 2015958239

For Roger, back roads guide and history guru extraordinaire.

CONTENTS

Acknowledgements 9
Introduction 11

1. From Slavery to the Gallows 17
2. Fatal Aversion 25
3. A Gambler's Demise 39
4. Gentleman George's Last Hurrah 47
5. Axe Murderer on the Loose 53
6. Triple Suicide or Sinister Plot? 63
7. Major League Nightmare 75
8. Slaughter of Innocents 85
9. "American Tragedy" on Lake Singletary 97

References 117
About the Author 121

ACKNOWLEDGEMENTS

A great many people generously contributed their time, resources and knowledge to the creation of this book. I wish to give special thanks to Dennis LeBeau and Frank Morrill for providing photographs from their William S. Bullard collection of glass negatives from the late 1800s and early 1900s. Bullard's remarkable photos help bring many of these stories to life.

I wish also to thank Brookfield historians Robert Wilder and Ronald Couture; New Braintree historian Connie Small; Barre Historical Society vice-president Margaret Marshall; Oakham Historical Association president Jeff Young; Brenda Metterville, director of the Merrick Public Library in Brookfield; Mary Baker-Wood, director of the Richard Sugden Public Library in Spencer; Roger Banks, Esq., who provided a copy of the *Commonwealth v. Newell P. Sherman* trial transcripts; Jaclyn Penny, Image, Rights and Design librarian at the American Antiquarian Society; Robyn Conroy, librarian at the Worcester Historical Museum; and all those who offered encouragement, input and suggestions throughout this project.

A heartfelt thanks to all.

INTRODUCTION

With its rolling hills, meandering waterways and sparkling ponds set amid lush and verdant woodlands, Worcester County in central Massachusetts presents a bucolic image. It's hard to imagine that anything truly awful has ever marred the seeming serenity of the sleepy old towns and historic city that occupy this pleasant landscape.

Yet from its earliest days as a colonial settlement right up to the present time, Worcester and its surrounding communities have been the scene of many violent and grisly crimes. Worcester itself was beset by violence from the start. The area was originally inhabited by members of the Nipmuc tribe, who called the region with its long, narrow pond "Quinsigamond," which means "pickerel fishing place." English settlers staked their claim to eight square miles of the land in 1674, but the settlement was burned to the ground on December 2, 1675, during King Philip's War, a bloody conflict between Native Americans and English colonists that engulfed much of New England.

A second attempt at settlement was made in 1684, but the town was abandoned in 1702 during Queen Anne's War when Native Americans again tried to reclaim their ancestral lands. When farmer Digory Sargent and his family refused to leave, he and his wife were slain.

Settlers claimed the land for a third time in 1713, changing the name "Quinsigamond" to "Worcester," after the city of Worcester, England. The town became the county seat of the newly founded Worcester County in 1731, and the citizens erected their first courthouse in 1733. Eight years later, they witnessed the county's first murder trial.

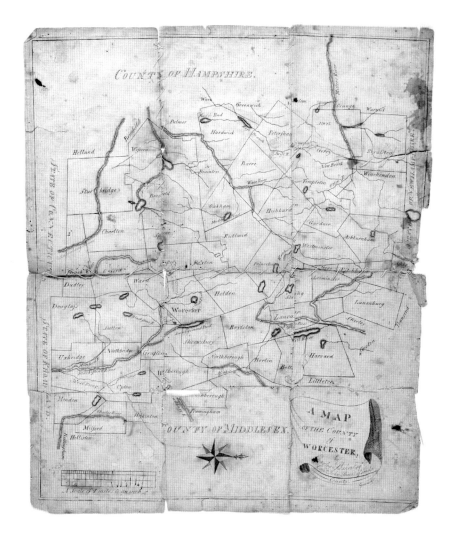

This map, published by Isaiah Thomas, shows Worcester County not long after it was established in 1731. *American Antiquarian Society.*

The murder occurred in Brookfield on September 29, 1741, during a husking bee on the farm of John Green, located midway on the present road from North Brookfield to West Brookfield. Green's son, Jabez, grew quarrelsome, boasting that he was ready to fight anyone and everyone who was present. In the ensuing excitement, he stabbed Thomas McCluer, who died of his wounds the following day. Green was arrested and conveyed to the Worcester jail, where he was held until the next term of the Superior Court of Judicature,

Court of Assize and General Jail Delivery, in Worcester, on September 21, 1742. Twenty-three witnesses were examined, and the jury found him guilty. On October 21, 1742, Jabez Green was hanged for his crime.

Executions were public events in Worcester's early days, attracting huge crowds and creating a carnival-like atmosphere. The hanging of Samuel Frost on November 5, 1793, was said to have drawn two thousand spectators. Frost had been tried for murdering his father in April 1784 but was acquitted on the grounds of insanity. Records don't show whether he spent any time in confinement, but on July 16, 1793, he murdered his employer, Captain Elisha Allen of Princeton, during an argument in a field on Allen's farm. Frost struck him more than fifteen times with the blade of a hoe and left his body lying on the ground. This time there was no acquittal. At the trial, he was found sane and sentenced to death.

Not everyone who was hanged in Worcester was convicted of murder. In fact, the first person to be formally executed in Worcester County was Hugh Henderson, who was hanged for the crime of burglary in 1737. Four other convicted thieves would follow. In all, seventeen men and one woman died on the gallows in Worcester. The last was Samuel J. Frost of Petersham, who murdered his brother-in-law, Frank P. Towne. The execution took place in the Summer Street jail on May 25, 1876. When the drop fell, Frost's head was nearly severed, and many of the witnesses fainted. After that, execution became a function of the state.

In cases where the death penalty wasn't applied, other penalties were meted out. One popular punishment was to sentence a wrongdoer to sit for hours on the gallows with a noose around his neck before being hauled off to jail. Other offenders might be sent to the pillory or whipping post, have their forehead branded or an ear cropped or be sold into bondage.

Early records show that Caleb Jephterson was sentenced to the pillory for an hour and a half "for the odious and detestable crime of blasphemy." Another man, James Trask, was convicted of fraud and sent to the pillory for one hour, "whipped thirty stripes" and then, because he was unable to pay a substantial fine, sold into bondage for four years.

In 1790, Revolutionary War hero Colonel Timothy Bigelow was thrown into the old stone jail on Lincoln Street in Worcester for nonpayment of a debt. The jailer's well-worn ledger reads, "Colonel Timothy Bigelow: Committed February 15—Discharged by Death April 1, 1790." Colonel Bigelow's fate is a reminder that life in "the good old days" was often hard and justice harsh. Although it is tempting to regard the past nostalgically— to imagine a simpler time when people were happier, kinder or more good-

A POEM

Occasioned by the untimely
Death of *Hugh Henderson,*
alias **John Hamilton,** who was
Hang'd at *Worcester* for House-
Breaking. Nov. 24. 1737.

Where with like Haste, thro' different Ways they
Some to undo and some to be undone. (run,
　　　　　　　　　　　　　Sir J. DENHAM.

How fatal is the Sinner's Path !
　　How surely does it lead to Death !
　　A while he treads with jocund Heel,
　　The dang'rous Road, nor dreams of Ill.
Till sudden Oppositions rise,
Trip up the Wretch, and close his Eyes.
The Scene we did but lately view
Too well evinces this is true.
A Man with healthful Vigour bless'd,
The Morn of Life but hardly past,
Compell'd to leave the pleasing Light,
And *stretch away* to endless Night ;
Because regardless of his Peace,
He chose the flow'ry Path of Vice.
He, by his Maker's gracious Care,
Drew his first Breath in Christian Air.
Where lovely VERTUE reign'd and smil'd,
And pure Religion, undefil'd
His Parents early sought his Good,
And *Baptism* gave him to their GOD.
But soon, too soon for him ! they dy'd,
And bid an Uncle be his Guide.
This Man, regardless of his Soul,
Gave him the Reins without controul.
But when he met with no Restraint,
And found his Uncle was no Saint,
In Vice's pleasing Steps he ran,
By swift Degrees, and rose to Man.
Now with no fear of GOD possest,
No Spark to kindle in his Breast
The sacred Flame, which might impart
The Pangs of Conscience to his Heart,
To ev'ry Crime devote he fell,
And vow'd to tread the Road to Hell.
Through all the Story should I run,
The Day would sooner far be done.
　Resolv'd to Sin, Men quickly find
(Too soon !) Companions to their Mind.
When long his Sins had anger'd GOD,
And *Armagh* groan'd beneath the Load,
The foolish Wretch, absurdly bold,
(Now twenty Winters he had told).
Left his *Hibernian* native Plain,
And dar'd to cross the threat'ning Main.
At length, unhappy, there he came,
And soon diffus'd his impious Fame.
Nor long abode, before he knew
Each Son of Vice, a dreadful Crew !
The Days in Laugh and Merriment,
And ev'ry Joy of Sense they spent.
In Drink, and Songs, and noisy Play,
Quick flow'd their jovial Hours away.
Now Cards, now Dice would intervene,
And fill the Day——A hellish Scene !
But when the dusky Night came on,
And Stars succeeded to the Sun,
When Villains more securely rove,
And, fearless, every Crime will will prove,
Debauches half the Night did fill,
And ev'ry cursed Work of H——.
The sensual Joys, and low Delights
That Women give, clos'd all their Nights.
Yet madly they for such a Bliss,
Disdain'd a future Happiness :
In their luxuriant Arms they lay
Dissolv'd, and curs'd th' approaching Day.
　Thus for a while his Hours did run,
Thus easy flow'd his Minutes on.

But lo ! the Scene no more appears,
Chang'd all to Grief, to Sighs, to Tears.
Wholly (poor Wretch !) by *Sin* possest,
No Spark of Grace to warm his Breast,
That all it's Paths he might pursue,
Must go and *break up Houses* too.
(As if his Sins were yet too light
To sink him to Hell's boundless Night !)
Avenging Heav'n now saw his Time,
At once to punish ev'ry Crime.
He bids stern *Justice* give the Due
To Crimes of such an odious Hue.
'Tis done—— How alter'd now his State !
Consign'd to *ignominious* Fate.
His various Crimes, confin'd, to mourn,
Unpity'd, needy, and forlorn.
O HENDERSON ! unhappy Man !
How did'st thou feel, when in thy Ken,
The best was Horror, like Despair,
Amazing Doubt, or anxious Fear ?
What Fangs, what Extasys of Smart
Convuls'd thy poor, thy bleeding Heart.
When in that State were bro't to Mind
Th' unnumber'd Crimes of Life behind ?
How could thy Tho'ts O ! then explore
(Tormenting Prospect !) Scenes before,
And Worlds, far distant hence, that lie
Beyond the reach of mortal Eye,
And not, with various Passions tos'd,
Be in the Maze of Horror lost ?
Howe'er, before his Time was come
To meet his *vile inglorious* Doom,
His Eyes were open'd, and his Heart
Felt Pangs of Penitential Smart.
ALMIGHTY POW'R subdu'd his Soul,
Rouz'd every Spring, and prov'd the Whole.
GRACE bid him see with Joy his Way,
Thro' JESUS, to the Realms of Day !
　But still he could not bear to dye.
(With all Heav'ns Glories in his Eye)
Till he had shown his Zeal for God,
And bid the Sinner fear his Rod ;
Bid 'em regard a future State,
E'er Death surpriz'd 'em to their Fate
　Thee, WORCESTER ! with many a Tear,
He beg'd to use thy utmost Care,
Rising Disorders to suppress,
And curb the daring Sons of Vice.
'Bove all, the vile *Intemperate,*
Who scorns his sure, tho' ling'ring Fate
That he no longer may disgrace
(Degen'rate Brute !) the humane Race.
　RHODE-ISLAND ! Thee how did he warn,
With honest, generous Concern,
To think upon thy State, nor more
Pursue the Bottle, Dice, and W——
　In fine, how loudly did he call
(The Voice impartial, and to All)
To shun th' alluring Snares of Death,)
And wisely press fair VIRTUE's Path.
VIRTUE ! O Goddess Heav'nly bright !
What real Pleasure and Delight
(To MAN scarce known NOW) do'st thou give,
To those who Thee their GUIDE receive.
Thro' the dark, cheating Maze of Life,
To free each Scene from Vice's Strife ;
Guiltless their chearful Minutes run,
And ev'ry Hour rolls gently on
And when their Father calls 'em home,
They smile, lie down, and meet their Doom,
And rise where boundless Fields of Joy and Glory
　　　　　　　　　　　　　　　(bloom.

F I N I S.

The Confession and Dying Warning of

Hugh Henderson,

Who was Executed at *Worcester*, in the County of *Worcester*, Nov. 26. 1737.

Sign'd by him in the Presence of four of the Ministers, the Morning of the Day of his Execution.

I *Hugh Henderson*, otherwise through my Wickedness called *John Hamilton*, of about 28 or 29 Years of Age, was born in *Ar-agh* in the Kingdom of *Ireland*, received Baptism in the Manner of the Presbyterians, and was brought up by my Uncle, who was obliged to give me suitable Learning, but did not ; which neglect, together with my own neglect of learning the Word of God afterwards, was a great Reason of my taking to such wicked Courses as have brought me to my unhappy, untimely End.

I began with smaller Sins while I was Young ; with but stealing Pins ; against which I received Warning oftentimes, but persisted in it, and was very disobedient, till I increased further in Sin.

I came into this Country about nine Years ago, and presently took to *Drinking* ; and when had been about a Year here, I took to *Stealing*, which I have followed from that Time, except two or three Years intermission ; and have lived in profane *Cursing*, *Swearing*, and *Lying*, and breaking the *Sabbath*, and *Gaming*, especially whilst I was in *Rhode-Island* Government ; to which I have added *Whoring* also : So that my Sins have been very many and hainous in the sight of God and Man ; but particularly I confess my *House-breaking*, for which I must justly die, and am righteously expos'd to the Wrath of God for ever.

But I have my Hope and Dependance upon the Lord *Jesus Christ* for the Pardon of many and great Sins, and for eternal Salvation : For he has come into the World to bear the Sins of Men, has suffered upon the Cross, and made Atonement by his Blood : In Him I desire to believe with my whole Soul, repenting bitterly of all my Sins, and forsaking and renouncing them all ; begging and hoping for Pardon at the Hands of God only for the sake of Jesus Christ.

I also entreat Forgiveness of all Persons whom I have wronged and injured by my Acts of Unrighteousness and Violence, or other Wickedness.

I desire to bless God he has given me such a sight and Sense of my Sins, and has granted me such a Space for my repenting, and affording me the precious Means of Grace, when he might have justly cut me off suddenly in the midst of my Wickedness.

I thank God also for the many Favours and kindnesses of his People and Ministers, and the helps and Assistances afforded me during my Imprisonment.

I thank God I thank his Excellency the Governour for his Compassion towards me in granting me a *Reprieve*, and am sorry that I have not improv'd the whole time of it better than I have ; but trust it has been a Mercy to my Soul.

And being that my Sins have brought me to these miserable Sufferings, I would solemnly Warn all Persons *in General* that they beware of sinning against an holy God as I have done ; and I pray God to keep them from the Sins I have been guilty of ; from *Whoring* and Drinking, breaking the Sabbath, Cursing and Swearing, and Lying and Gaming ; and from Stealing especially.

I would *particularly* warn all *Parents & Heads of Families* that they neglect not Prayer in their Houses, and that they do not fail to bring up the Children under their Care in suitable Learning, and in the Knowledge and Fear of God and Practice of Religion, that they may not fall into such pernicious Courses as I have done.

I would solemnly Warn all *Children* and *Servants* that they be sure to be obedient to their Parents, and Masters and Mistresses : Disobedience being a dangerous Inlet to much other Wickedness.

And I solemnly warn all *Young Persons* that they especially beware of the forementioned heinous Sins, and they do not by any Means neglect the Care of their Souls, but see that they be busy with God in their Youth, acquaint themselves with Christ and the way to Salvation by Him, accept of Him, and rely upon Him for eternal Happiness.

I would earnestly Warn and Charge all *Tavern Keepers* that they mind and give good Weight and Measure, there being much Iniquity through the neglect thereof, and see that they keep good Orders, and do not let Persons have too much Drink, being that by those Means they become in a great Measure chargeable with the Sins which others commit when depriv'd of their Senses thereby. I pray the Tavern Keepers of this Town of *Worcester* that they would beware of suffering any Disorders in their Houses, letting the young Persons, or the younger or elder Persons of the Place continue in their evil Practices of drinking to Excess.

And while I remember what pass'd with me in *Rhode-Island* Government, I can't but warn them against their rudeness, viciousness, irreligiousness, and breaking the Lord's Day.

Having given this Warning, I desire to commend my self to the Charity and Prayers of all God's People for me, and that you would lift up your Hearts to God for me, for the Pardon of my Sins, an Interest in Christ, and that I may be sanctified by the Spirit of God : But above all I commend my self to the infinite Mercy of God, in my dear Redeemer, begging and beseeching that through the Merits of his Blood I may this Day be with Him in Paradise.

Hugh Henderson.

Sign'd with his Mark.

A true Copy Examin'd,
Per Eb' Parkman.

BOSTON : Printed and Sold at the Printing House in Queen Street over against the Prison.

A poem and "Dying Warning" publicized the hanging of Hugh Henderson for burglary in 1737. He was the first person formally executed in Worcester County. *American Antiquarian Society.*

hearted than they are today—dishonesty, conflict and violence have always been with us. Our definition of crime and methods of punishment change with the times. The scales of justice tilt alternately toward severity or leniency.

But human nature doesn't change. The men and women whose stories are told on the following pages are proof of that. From the escaped slave who was hanged for rape in 1768 to the Sutton choir singer who was convicted of drowning his wife in 1935, all were motivated by the same fearsome impulses that lie behind most of today's violent crimes: lust, greed, rage, hate, fear, despair or madness—or the unlocked secrets of the human heart.

FROM SLAVERY TO THE GALLOWS

As he sat in the Worcester jail awaiting execution in October 1768, escaped slave Arthur Toby produced a vivid account of his crime-filled life.

> *I would solemnly warn those of my Color, as they regard their own souls, to avoid Desertion from their Masters, Drunkenness and Lewdness; which three Crimes was the Source from which have flowed the many Evils and Miseries of my short Life. Short indeed!*

So declared twenty-one-year-old Arthur Toby in his "dying speech" from the Worcester jail on October 18, 1768—two days before he was hanged "for a rape committed on the body of one Deborah Metcalfe." The execution was the final act of a crime-filled life in which Arthur gained notoriety as one of colonial New England's most incorrigible miscreants.

His firsthand account, which was printed in Boston and sold to an eager audience, paints a complex picture of daily life in Massachusetts before the Revolution. In Arthur's world, slaves were bought and sold, Native Americans lived in separate settlements, farming was the primary occupation, whaling was a thriving industry, taverns and inns were common gathering places, husking bees were important social events…and justice was swift.

BORN A SLAVE

Arthur Toby entered the world as the child of a slave in the household of Richard Godfrey, Esq., of Taunton, Massachusetts, on January 15, 1747. He was taught to read and write and, in his own words, was "treated very kindly by my Master." But he was often in conflict with Mrs. Godfrey, and at the age of fourteen he ran away. This, he says, "was the beginning of my many notorious Crimes, of which I have been guilty."

He headed for Sandwich, a Cape Cod town about forty miles away. There, he confesses, he spent his time in "Drunkenness and Fornication; for which crimes I have been since famous." After stealing a shirt and paying restitution of twenty schillings, and concerned that his "Character being now known," he decided to ship out on a whaling sloop with Captain Coffin of Nantucket. (The Coffins were a prominent whaling family for almost two hundred years.)

Eight months at sea did little to reform Arthur's behavior. When he returned to Nantucket, he embarked on a six-week crime spree. At one point, he broke into a store and stole rum, a pair of trousers, a jacket and some calico. He was drunk the next day, "and by wearing the Jacket, was detected, for which Offence I was whip'd with fifteen Stripes, and committed to Gaol, for the Payment of Cost." He escaped a half hour later by breaking the lock.

After another burglary, he attempted to escape on a ship but was discovered, taken on shore and whipped "sixteen Stripes." He was set free and returned to Taunton, "where my Master received me kindly, whom I served three Years." During that time, he "followed the Seas," sailing from Nantucket and Newport to the West Indies, "where I whored and drank, to great Excess."

In October 1764, he again returned to live with "my Master in Taunton, where I behaved well for six Weeks." But he was soon in trouble again. One day while intoxicated, he entered a house "where were several Women only" and offered "Indecencies" to them. He was discovered by James Williams, Esq., who with the assistance of Job Smith placed him in the Taunton jail. The next day, he was tried before the same Mr. Williams and whipped "thirty-nine Stripes for abusing him, uttering three profane Oaths, and threatening to fire Mr. Smith's House."

A New Master

Out of patience with his troublesome slave, Richard Godfrey, "being now determined, by the Advice of his Friends, to send me out of the Country," sold Arthur to John Hill of Brookfield. After only a week, he was sold to "my last Master, Capt. Clarke of Rutland District [now Barre], where I behaved well for two Months, and was very kindly treated by my Master and Mistress."

But Arthur soon struck up an acquaintance with "a young Squaw, with whom (having stole Six Shillings from one of my Master's Sons)" he ran away. His companion—who "like the rest of her Sex, was of a very fruitful Invention"—helped him disguise himself as a Native American woman carrying a papoose. Together, they made their way to Hadley, about forty miles away. There, he spent the night with an Indian family before being discovered in the morning by "by one Mr. Shurtleff, a Person who had been sent after me; with him I went to Springfield, where I met my Master, who took me down to Middletown with a Drove of Horses, where he sold me to a Dutch Gentleman, whose Name I have since forgot."

Soon after his arrival in Middletown, he stole five pounds from the keeper of a public house, a "Widow Sherley," and spent the money on liquor. His theft was discovered and he was taken into custody, but he escaped to Farmington, where he was apprehended and returned to his former master, Captain Clarke. The reunion was short-lived: "My Master being now wearied by my repeated Crimes, was determined to part with me: And accordingly we set off for Boston, at which Time I took two Dollars from my Master's desk."

The journey to Boston was not without incident. Arthur "tarried" in Waltham and joined in a husking bee in Little Cambridge. There, he was introduced to "a white Woman of that Place: And as our Behaviour was such, as we have both Reason to be ashamed of, I shall for her sake pass it over in Silence."

He set out for Boston the next day—with the lady's husband in hot pursuit. Eventually, the two "came to Blows, and I coming off Conqueror, put on for Cambridge." But the matter was not settled. After stealing a horse, saddle and bridle to spend the day with "the Squaw, with whom I formerly made my Tour to Hadley," Arthur was sentenced "to receive fifteen Stripes, or pay four Dollars." Captain Clarke paid the fine, and upon learning that the injured husband had obtained a warrant for Arthur's arrest, he went ahead to Boston to secure his slave a berth on a ship. Arthur explained that

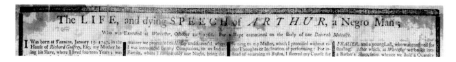

The LIFE, and dying SPEECH of ARTHUR, a Negro Man;
Who was Executed at *Worcester*, October 20ᵗʰ 1768. For a Rape committed on the Body of one *Deborah Metcalfe*.

I Was born at *Taunton*, January 15 1747, in the House of Richard *Godfrey*, Esq; my Mother being his Slave, where I lived fourteen Years ...

Arthur Toby recounted his many crimes in a broadside titled "The Life and Dying Speech of Arthur, a Negro Man." *American Antiquarian Society.*

Clarke "order'd me to come in the Night: In Pursuance of which Order, I set off, but having a natural Aversion to walking, for my own Ease, and that I might make the greater Dispatch, I took a Horse from the Stable of one Mr. Cutting, rode to Roxbury, and let him go."

He eventually met up with Clarke, who advised him "to tarry 'till the next Day, when I should be taken on board a Vessel bound for Maryland." But Arthur failed to follow through. He stole another horse, this time to visit his parents, who "insisted on my returning to my Master." Instead, he made his way to Sandwich, visiting "an Indian House, where I had been formerly acquainted, and with the Squaws there, spent my Time in a manner which may be easily guessed."

He was apprehended and held for trial but quickly escaped and returned to the Indian village, "spending my Time in drinking and whoring with the Squaws." Then he went to Falmouth and stole shoes from a shoemaker's shop and some clothes from a private home. He stole a horse for the return trip to Sandwich and spent another week in the Indian village before being apprehended and committed to Barnstable jail.

He was tried and "sentenced to receiving twenty Stripes." But Arthur was ill, and taking pity on him, the man whose horse he had stolen took him out of jail, "so that I again got off unpunished; With him I lived about three Weeks, and behaved well." Characteristically, Arthur's good behavior was short-lived.

Captain Clarke was sent for and once more took the young man home, perhaps hoping that he had changed his ways. But when an acquaintance informed Arthur that "the young Squaw, so often mentioned, was desirous of seeing me," he "stole some Rum from my Master, got pretty handsomely drunk, took one of his Horses, and made the best of my way to her usual Place of Abode."

A FATEFUL DECISION

To his great disappointment, the woman was not home. Drunk, reckless and itching for female companionship, Arthur made the fateful decision that would lead to the gallows: "The Devil put it into my Head to pay a Visit to the Widow Deborah Metcalfe, whom I, in a most inhumane manner, ravished: The Particulars of which are so notorious, that it is needless for me here to relate them."

The next morning, the distraught woman told Clarke what had happened. He immediately tied Arthur up to prevent him from escaping and advised the woman to obtain a warrant. But she was reluctant to see him hanged and suggested that Clarke should instead send him out of the country. Clarke agreed, and the two set off for Albany.

They were overtaken by Nathaniel Jennison, who had obtained a warrant for Arthur's arrest. On the return to Rutland, he said:

> We stop'd at a Tavern in Hardwick, where after I had warmed myself, Jennison was Fool enough to bid me put along, and he would overtake me; accordingly I went out of the Door, and seeing his Horse stand handily, what should I do, but mount him, and rode off as fast as I could, leaving Jennison to pursue me on Foot.

Back at home, Arthur spent the night in Clarke's barn, "where I had a Bottle of Cherry-Rum (which I found in Mr. Jennison's Baggs) to refresh myself with."

The next day, March 30, 1767, Arthur was discovered and committed to the Worcester jail. One of his cellmates was Isaac Frasier, known as the "Notorious Frasier," a young man from Connecticut whose criminal career closely matched Arthur's own. They and another inmate broke out on April 20 and set off for Boston. For several months, they traveled on foot, living in the woods and stealing food, clothes and other items along the way, including a comb, a razor and a "quantity of flour" from a Worcester barbershop.

"At Waltham," Arthur continued, "we broke into a House belonging to one Mr. Fisk, from whom we took a small Sum of Money, some Chocolate and Rum. At Watertown we stole a Brass Kettle from one Mrs. White of that Place."

For reasons he doesn't explain, Arthur and his companions eventually parted company. He decided to return to "Mr. Fisk's in Waltham, who knew

me," perhaps hoping the man would help him escape prosecution. He did not. Fisk secured him and returned him to the Worcester jail. Within a year, he was tried, found guilty and sentenced to death.

To the Gallows

Arthur Toby went to the gallows on October 18, 1768. A large and boisterous crowd was on hand to watch the twenty-one-year-old die. One month earlier, his companion, the Notorious Frasier, had been hanged at Fairfield, Connecticut, for multiple burglaries.

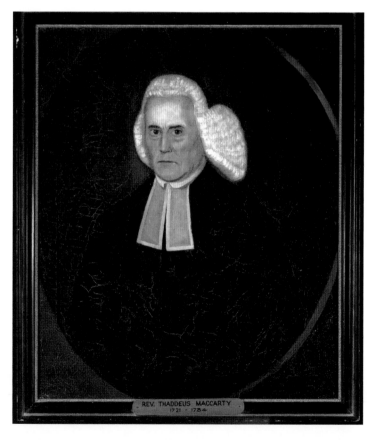

As minister of Worcester's First Church for nearly forty years, Reverend Thaddeus Mccarty provided spiritual guidance to many prisoners. *American Antiquarian Society.*

What drove young Arthur Toby to a life of crime? Was it rebellion against the inherent injustice of being a slave? Did the political unrest and economic instability of the times come into play? Was he constitutionally incapable of learning from his mistakes? Or, like many criminals, was he drawn to the excitement of living outside the boundaries of conventional behavior?

We'll never know. But we do know that near the end of his life, his thoughts turned to redemption. His narrative concludes with words of gratitude to Reverend Thaddeus Mccarty—minister of Worcester's First Church for nearly forty years—for his "unwearied Pains, Exhortations, and most fervent Prayers," and with a plea for forgiveness:

> *I freely acknowledge I have been better treated by Mankind in general, than I deserved: Yet some Injuries I have received, which I now freely forgive. I also humbly ask Forgiveness of all whom I have injured, and desire that they would pray that I may receive the Forgiveness of God, whom I have most of all offended; and on whose Pardon and Grace depends my eternal Happiness or Misery.*
>
> *Worcester Gaol Oct. 18, 1768*
> *Arthur*

FATAL AVERSION

Bathsheba Spooner of Brookfield became the first woman executed in the United States when she and three accomplices were found guilty of murdering her husband in 1778.

Around nine o'clock on the wintery Sunday night of March 1, 1778, Joshua Spooner, a prosperous thirty-seven-year-old businessman living in Brookfield, Massachusetts, left Ephraim Cooley's tavern and walked the quarter mile to his home.

The tavern was a congenial place where neighbors regularly met to share gossip and news of the day. The war with England, now in its fourth year, was undoubtedly at the forefront of everyone's mind. A good many of Brookfield's finest young men were fighting for the cause, and the Continental army had proved its mettle yet again. Last October, General Horatio Gage had won a stunning victory over General John Burgoyne at Saratoga. The battle was a turning point, emboldening France to pledge its support for the Patriots' struggle for independence.

Veterans of the battle, both Redcoats and Patriots, were a common sight as they traveled along the New York to Boston Post Road, which ran through Brookfield. Spooner's house, a substantial two-story dwelling, lay on that road.

As he approached his house that night, Spooner's thoughts may have turned to an unsettling incident that had occurred about two weeks earlier. Upon his return home from a trip to Princeton, Massachusetts, where he owned a potash business, he had found two British soldiers enjoying his wife's hospitality. As the daughter of a notorious Loyalist, she may have felt no

qualms about welcoming them into her home. But Spooner was suspicious. He had ordered them to leave first thing in the morning and threatened to summon town authorities if they didn't comply.

To be on the safe side, he had slept with his lockbox under his head and asked a visiting friend to stay with him through the night. In the morning, the soldiers were gone, but rumor said they were still in the neighborhood. Did he think of those soldiers as he approached the gate that night? Did he feel a prickle of unease that might have caused him to hesitate? We'll never know.

What we do know is that Joshua Spooner lifted the latch and entered his yard. His house was dark except for a few narrow windows dimly lit by the hearth's yellow glow. Snow blanketed the ground. A deep silence lay all around. Then, from out of the darkness, villains fell upon him, reigning blows on his head and shoulders, knocking him to the ground, kicking him with their boots and choking the life from him. He struggled to escape or cry out for help. But there were three of them, and he was not a vigorous man.

In the morning, neighbors found his battered lifeless body where his assailants had flung it—headfirst in his own well.

A Quick Arrest

The first person to raise the alarm was Alexander Cumings, a servant in the Spooner household. Bathsheba Spooner, Joshua's wife, informed him that her husband had not come home last night and ordered him to inquire at Cooley's tavern. Upon hearing the news, Ephraim Cooley immediately organized a search party of seven men, including himself.

The searchers came upon a disturbing scene. The snow in Spooner's yard was heavily trampled, as if some violent activity had occurred there. In the heap of snow near the gate, they found Spooner's hat. They then spotted two splotches of blood on the rim of the nearby well. When they peered inside, they saw a body undoubtedly belonging to Joshua Spooner.

Cooley set off to alert the coroner and an officer while the others raised the body from the well. The coroner, Dr. John King, and his wife had spent the previous evening with Spooner and other friends at Cooley's tavern. When he arrived at the Spooner home that morning, he found the victim on the ground with severe bruising about the face and a cut on the scalp. The men carried the body into the house and placed it in the east room to await burial. It was a somber business, and Bathsheba was visibly upset.

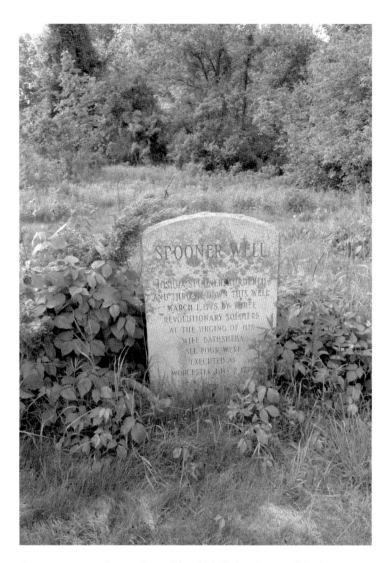

A monument stands near the well in which Joshua Spooner's body was found on March 2, 1778. *Author's collection.*

The household was large: two daughters aged ten and three, an eight-year-old son, three servants and several visitors. The family, with the exception of Spooner's younger daughter, at first refused to look at the body. Eventually, Dr. King persuaded Bathsheba to view her dead husband. After a long silence, she placed her hand on his forehead and murmured, "Poor little man."

News of the crime swept through the region. The brutal murder of a prominent citizen at his own doorstep raised considerable alarm. Town officials quickly formed a jury to conduct an inquest. On March 3, the jury reported that Joshua Spooner "was feloniously assaulted by one or more ruffians…and thrown into his own well with water in it, by persons to the jury unknown."

Suspicion fell on the two British soldiers who were known to have been at Spooner's house not long before his death—twenty-seven-year-old William Brooks, an Englishman, and thirty-year-old James Buchanan, a Scotchman. Both had served with Burgoyne at Saratoga. Under the terms of surrender, British officers had been allowed to return home, while the enlisted men were marched to Cambridge to await being shipped back to Europe. Billeted in crude barracks and private homes, about 1,300 of the 5,900 captives escaped. Buchanan and Brooks were among them.

They were found at Brown's tavern in Worcester, where Brooks was wearing Spooner's silver buckles and showing off his watch. The two were immediately arrested, along with seventeen-year-old Ezra Ross, an American soldier and known intimate of the Spooner household. He was found hiding in the tavern loft.

All three were questioned. Their statements, along with the circumstances of the murder, aroused strong suspicions that members of Spooner's household were also involved. Bathsheba was arrested—as were three servants who were later used as witnesses—and taken to Brown's for questioning. There, she wept as she talked of the matter and said openly that she was responsible for the murder being committed.

Brooks, Buchanan, Ross and Bathsheba Spooner were detained until the next session of the Superior Court of Judicature, set to commence on April 21, 1778. On that day, a grand jury indicted all four for murder. The trial was scheduled for April 24. Robert Treat Paine, a signer of the Declaration of Independence, was the attorney for the state. Levi Lincoln, who would later serve as attorney general under Thomas Jefferson, was appointed counsel for the prisoners. During the trial, which was completed in one day, twenty-two witnesses testified for the prosecution. No witnesses were called for the defense.

The testimony, along with the soldiers' signed confessions, wove a disturbing tale of an unhappy marriage, a desperate woman and an ill-conceived plot.

The Plot Unveiled

Bathsheba Ruggles and Joshua Spooner were married on January 15, 1766, when she was twenty and he was twenty-five. He was the third son of John Spooner, a wealthy Boston commodities merchant who had emigrated from England. She was the sixth child and reputedly favorite daughter of Brigadier General Timothy Ruggles, a distinguished lawyer, legislator and military leader who held some of the most important offices in the colony. A Harvard graduate, as was his father, Ruggles was the fifth generation of his family born in America.

Bathsheba's mother was Bathsheba Bourne Newcomb, a *Mayflower* descendant, daughter of the wealthiest man in Sandwich, Massachusetts, and owner of the Sandwich tavern. She married Timothy Ruggles—he was twenty-five, she was thirty-two—within five months of burying her first husband, with whom she had had seven children. Her father, Judge Melitiah Bourne, officiated at the wedding.

In 1753, Timothy and Bathsheba Ruggles, who had seven children of their own, moved along with six other Ruggles families to Hardwick, a new town about twenty-five miles west of Worcester. There, they lived in high style on their four-hundred-acre property. They laid out and stocked a deer park and bought and bred excellent hunting and riding horses, prize bulls and a superb dairy herd. They established an orchard with many varieties of fruit. They frequently entertained notable guests and hosted lavish dinners.

Timothy's career flourished. He served as Hardwick's representative to the General Court for seventeen years and proved himself an able officer with exceptional leadership skills throughout the French and Indian War (1754–63). For his efforts, the Crown awarded him £300 per year and a grant of 1,500 acres in nearby Princeton. He was also named chief justice of the Worcester Superior Court. A young John Adams wrote admiringly of Ruggles's "steadiness of attention," "boldness and strength of…thoughts and expressions," "strict honor, conscious superiority, and contempt of meanness."

Compared to such a man, Joshua Spooner undoubtedly fell short, especially in his wife's eyes. Although their home was comfortable and even elegant by contemporary standards, in court dispositions Joshua emerged as a weak man who was easily intimidated and unable to establish himself as manager of his household affairs. Bathsheba, on the other hand, was by all accounts strong-willed, outspoken and imperious. Their marriage was commonly known to be an unhappy one, and she developed what some

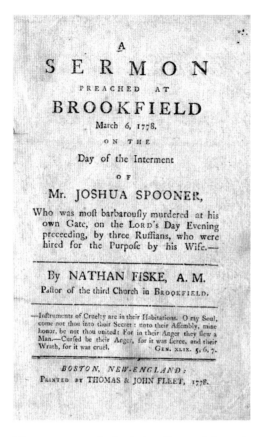

The sermon preached at Joshua Spooner's funeral service on March 6 proclaimed Bathsheba's guilt. *American Antiquarian Society.*

described as an "utter aversion" to her husband.

The great upheaval of the Revolutionary War deepened the rift between these temperamentally incompatible people. Timothy Ruggles was a staunch Loyalist whose support of the Crown never wavered. Vilified by the Patriots, in 1774 he was forced to flee Hardwick for Boston, which was then held by the British. He eventually moved to New York, where he spent much of the Revolution on Staten Island before relocating to Nova Scotia with about forty thousand other Loyalists when the war ended. His property was confiscated, his wife stayed behind and he never saw his favorite daughter again. Bathsheba must have felt the loss, not only of her family's social position but also of the most important man in her life. But in March 1777, another man came along who would change her life forever.

Ezra Ross was only sixteen years old when he passed through Brookfield that spring, but he had already fought in the Continental army for a year. He was walking from Washington's winter camp in Morristown, New Jersey, to his family home in Ipswich, Massachusetts, a distance of about 280 miles. It was a harsh winter, and he fell ill with fever.

Bathsheba took him into her home and nursed him back to health. As his health improved, the two of them were frequently seen riding together in the country. One observer recalled "seeing Ross and Mrs. Spooner riding on horseback together, the former was a fine looking youth, and the beauty of the latter, who was a remarkable horsewoman, has not been exaggerated in the least by traditional accounts."

Ezra visited the Spooner home again on his way to rejoin the army in July and again in December after the Saratoga campaign, when he stayed through Christmas and into the new year. Joshua seems to have taken a liking to the young man, who began to accompany him on short business trips. But the relationship between Bathsheba and Ezra deepened into something far warmer than friendship.

Early in 1778, Bathsheba realized that she was pregnant. She soon began to urge young Ezra to do away with her husband. In February, she gave him a vial of nitric acid and pressed him to put it in Joshua's nighttime toddy during a business trip to Princeton. Ezra initially agreed, but he backed out and went directly from Princeton to his parents' home in Ipswich.

During Joshua and Ezra's absence, Bathsheba's behavior became increasingly irrational. Apparently unsure of her lover's resolve to poison her husband, she ordered a servant to invite into the house any British soldiers who happened to be passing by. In this way, Brooks and Buchanan—who were heading from Cambridge to Springfield, Massachusetts—first made her acquaintance. She invited them to stay while her husband was away and lavished them with food and drink. She talked freely of her desire to kill her husband and promised to reward them handsomely if they would help her.

After Joshua's return, the three of them began to meet secretly to plot his murder. One idea was to smother him in his bed and dump his body in the well so people would think he had fallen in while drawing water in the night. Another idea was to tell Joshua that one of the horses was sick and then kill him in the barn and place his body among the horses' feet. The plotters also discussed poisoning Joshua with calomel, and Brooks purchased a quantity for this purpose. But nothing came of these plans.

Then, on March 1, Ezra returned to Brookfield at Bathsheba's written request. When Brooks and Buchanan arrived in the evening, Bathsheba invited them into the house, where they met Ezra for the first time. He had a pair of pistols and proposed shooting Joshua. But the older men objected, saying the noise would attract neighbors' attention. Instead, they agreed to attack him when he returned from the tavern. According to their dying confession:

> William Brooks went out and stood near the small gate leading into the kitchen, and as Mr. Spooner came past him he knocked him down with his hand. He strove to speak when down. Brooks took him by the throat and partly strangled him. Ross and Buchanan came out; Ross took Mr.

Spooner's watch out and gave it to Buchanan; Brooks and Ross took him up and put him into the well head first; before they carried him away, I, Buchanan, pulled off his shoes.

After stuffing Joshua's body down the well, they went into the house. Bathsheba was in the sitting room and seemed "vastly confused." She immediately left the room and returned with the lockbox, which they had to break open because she didn't have a key. She gave them approximately $300 as well as her husband's watch, silver buckles, a ring, waistcoat, breeches and shirts. Their own bloody clothes they burned in the fireplace.

Then the assassins set off for Worcester. They spent the next day drinking "to drown the horrid thoughts of the action we had been guilty of" and planned to leave town the following day. But news of the murder had spread, and the three were quickly apprehended. Committed to the Worcester jail—where Bathsheba would soon join them—they prepared to face the consequences of their dreadful deed.

THE GHASTLY GALLOWS

The trial of Bathsheba Spooner and her three co-conspirators caused a sensation. Her wealth and social standing, along with her father's notoriety, all brought a heightened sense of excitement to the case. The trial, which took place at Worcester's Old South Meeting House on April 24, 1778, was the first capital trial to be held under the newly formed United States government in Massachusetts.

The prosecution presented overwhelming evidence of the defendants' guilt. Among the witnesses were three of the Spooners' household servants: Alexander Cumings, Jesse Parker and Sarah Stratten. All were to some degree aware of the plot to murder Joshua, and all in some way facilitated the crime and were paid by Bathsheba to keep silent. But they escaped prosecution in exchange for their testimony.

The defense argued that since it was impossible to know which of the assailants had struck the fatal blow, the guilt of any of them could not be proved beyond a reasonable doubt. Furthermore, Lincoln said, Bathsheba was clearly of unsound mind and therefore not responsible for her actions. The jury was not persuaded. They found all four guilty of murder, and execution was set for June 4.

The trial of all four defendants took place on April 24, 1778, in Worcester's Old South Meeting House. *American Antiquarian Society.*

The verdict was a crushing blow to Ezra's elderly parents, Jabez and Joanna Ross. They submitted to the court a heartfelt petition to spare his life, citing his service to country, his youth, Bathsheba's culpability and their own anguish:

> [Of our] *seventeen children, six sons and three daughters alone survived to your aged and distressed petitioners…At the first instance of bloodshed, five of the six sons entered the public service; four fought on Bunker Hill. Three marched to the southward with General Washington, of which number was the unhappy convict…A fourth mingled at the northward his bones with the dust of the earth…*
>
> [Ezra was] *seduced both from virtue and prudence, a child as he was, by a lewd, artful woman…If he has been a valuable member of society, and has fought in her cause…if youth, if old age, the sorrows, the anguish of a father, the yearning of a mother…if any or all of these considerations can arrest the hand of justice, plead effectually for mercy, and induce your honors to extend that pardon.*

The court denied the petition. Bathsheba, however, made a petition of her own.

Throughout her confinement, she had remained remarkably composed, all the while maintaining her innocence. She claimed that although she had discussed murdering her husband, she had never believed that it would really happen. Now, facing execution in little more than a month, she revealed that she was pregnant and asked that the execution be delayed. Accordingly, the

execution was postponed for one month, and a jury of two male midwives and twelve matrons was summoned to examine Bathsheba. They returned a verdict that she was not "quick with child." She submitted a second petition, stating:

> *I am absolutely certain of being in a pregnant state, and above four months advanced in it…What I bear and clearly perceive to be animated, is innocent of the faults of her who bears it, and has, I beg leave to say, the right to the existence which God hath begun to give it. Your honors' human Christian principles, I am very certain, must lead you to desire to preserve life, even in this, its miniature state, rather than to destroy it.*

Her spiritual advisor, Reverend Thaddeus Mccarty of Worcester's First Church, the two male midwives, one of the matrons and Dr. John Green, Bathsheba's brother-in-law, all said they believed she was pregnant and sought a reprieve. But two of the matrons certified that a second examination showed she was not, and the order of execution stood. Bathsheba took the verdict calmly but requested that her body be examined after her death.

On July 2, 1778—four months to the day after Joshua Spooner's body was discovered—the prisoners approached the scaffold, near what is today Washington Square, at about half past two o'clock in the afternoon. The three soldiers went on foot.

Bathsheba, who was unwell, rode in a chaise provided by Reverend Mccarty. He later wrote of the experience:

> *I accompanied her in a carriage to the place of execution; she appeared undismayed and unaffrightened…At length we came in sight of the gallows. I asked her if the sight did not strike her? She answered not at all any more than any other subject. Her constitutional politeness remained.*

Suddenly, one of the most terrible thunderstorms in living memory broke out. The skies turned black. According to eyewitness accounts:

> *There followed the most awful half hour. The loud shouts of the officers amidst a crowd of five thousand people to, "make way, make way!" the horses pressing upon those in front; the shrieks of the women in the tumult and confusion; the malefactors slowly advancing to the fatal tree, preceded by the dismal coffins; the fierce coruscations of lightning athwart the darkened horizon, quickly followed by loud peals of thunder, conspired together and produced a dreadful scene of horror.*

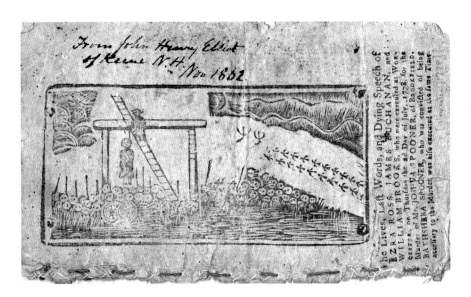

The co-conspirators' "Last Words and Dying Speech" depicted the hanging, not far from the courthouse where Bathsheba's father once served as chief justice. *American Antiquarian Society.*

The soldiers ascended the stage, where the death warrant was read. Ross prayed audibly. The others prayed silently. Bathsheba crept up the ladder on her hands and knees, smiling gently and nodding to people she knew.

When their faces were covered, for the first time she acknowledged that her punishment was just. She grasped the sheriff's hand. "I am ready," she said. "In a little time, I expect to be in bliss, and but a few years must elapse when I hope I shall see you and my other friends again." With that, she fell away into the vast unknown, not far from the courthouse where her father had served as chief justice of the Superior Court. In the evening, her body was examined by surgeons. The fetus of a five-month-old male was taken from her.

Ezra's grieving parents took his body home to Ipswich for burial in a family plot. Brooks and Buchanan were consigned to a pauper's grave. Bathsheba's sister, Mary—wife of Dr. John Green—took her body to their expansive estate in Worcester, where it remains buried in an unmarked grave. Some years later, the family bequeathed the land to the city for use as a public park, known today as Green Hill Park.

Lingering Questions

Over the years, Bathsheba Spooner has passed into legend. Some have cast her as an abused woman who rebelled against an oppressively male-dominated society. Others have seen her as a victim of anti-Tory fervor. Many have been especially appalled by the taking of her unborn child. Legal scholar Peleg W. Chandler wrote:

> It is surely a stigma upon the criminal jurisprudence of Massachusetts that the execution of Mrs. Spooner was not respited until the birth of her child. Even now…no one can read the story of this wretched woman, without a shudder at the fate of that mother, who made an ineffectual prayer for the life of the innocent one whose existence was so intimately and sacredly connected with her own.

Certainly, the unborn child compounded the tragedy, as did the fate of the three little children—Elizabeth, Joshua Jr. and Bathsheba—who were orphaned by their mother's desperate act.

We can never know what drove her to murder. During the trial, witnesses provided scant clues to her motivation. One quoted her as saying that she had "a great desire to see her Daddy, and if it were not for that, this murder would never have been committed." Another witness heard her say that "this happened by means of Ross's being sick at our house."

It's possible, as many have theorized, that she murdered her husband to avoid his discovery of her infidelity. But the truth may be simpler than that. She may simply have wanted to do away with a man she despised. Joshua Spooner—although apparently a competent businessman, liked by his neighbors and kindly enough to take Ezra Ross under his wings—was perhaps not a man who inspired respect. A few telling incidents emerge from the dying confession of Brooks and Buchanan.

When Joshua first discovered them in his house, Bathsheba falsely explained that Buchanan was cousin to Alexander Cumings. Joshua gave Cumings five dollars "to treat his pretended cousin with."

Later on, after Joshua had visited with neighbors, he learned "how long we had been there and the quantity of liquor he had to pay for." Joshua returned home and ordered them to leave immediately. But despite his misgivings, they persuaded him to let them stay the night. Joshua asked an acquaintance to spend the night with him, fearing that the two men would rob him, "which vexed us, as we were conscious we had no thought of

stealing from him." He also claimed that a silver spoon and quantity of pewter were missing, but the "spoon he found where he laid it and Cumings convinced him that none of the pewter was missing."

These derisive recollections paint a picture of a timid man who lacked authority, as does the testimony of a witness who recalled that "[Bathsheba] asked Mr. Spooner for a horse [to visit her sister in Worcester] but he declined letting her have one, and she sent to Captain Welden's and got his."

In this battle of wills, Bathsheba came out on top, which was likely true in most matters. After all, at her insistence, the servants concealed their knowledge of Brooks and Buchanan's numerous visits to the house while Joshua was away, and they did not reveal the plans to murder him, which were openly discussed. Bathsheba's own words upon seeing his body—"poor little man"—suggest a lack of respect for him. Her pregnancy may have provided the final impetus to escape a marriage that for her had become intolerable.

On the other hand, mental illness may be closer to the truth of the matter. A story has been handed down over the years that in a fit of pique, Bathsheba's mother once fed her husband, Timothy Ruggles, his favorite dog for supper. Bathsheba's sister Mary reportedly had a mental breakdown after the execution. And young Bathsheba—three years old at the time of her father's murder—was confined to a mental institution for decades until her death at the age of eighty-three. It's entirely possible that Bathsheba herself carried some strain of mental instability, made worse, perhaps, by the turbulent times in which she lived.

Whatever her motivation, Bathsheba's story continues to intrigue and trouble us today.

A GAMBLER'S DEMISE

*In 1868, cousins Silas and Charles T. James were hanged for the murder of Joseph
G. Clark, a professional gambler who cut a dashing figure in Worcester's underworld of
taverns and gambling rooms.*

Another Shocking Murder!" declared the headlines of the *Worcester
Evening Gazette* on February 29, 1868. "A Gambler the Victim!"

The murder—Worcester's second that winter—had taken place the night
before in the Union Block apartments next to Mechanics Hall, one of the
nation's finest pre–Civil War concert halls. The George H. Ward Post, GAR,
was hosting its first ball in the elegant building, and about three hundred
guests were in attendance as the sinister scene unfolded next door.

Around seven o'clock on the evening of February 28, a woman calling
herself Mrs. Eaton went up to Joseph G. Clark's rooms on the third floor of
the apartment building. Clark, a professional gambler, was about forty-five
years old, with dark hair, a full beard and a powerful physique. For about
two years, he "had been in intimate, unlawful relations with a certain young
woman, of uncertain reputation, called Mrs. Eaton," reported the *Gazette*.

Mrs. Eaton heard noises from inside Clark's rooms, but the door was locked
and he didn't respond to her appeals for admittance. Growing frustrated, she
announced that she was leaving and would return in about half an hour.

But jealousy overcame her. Suspecting that Clark was entertaining some
rival, she quickly returned to the building and demanded that he let her in.
Again, she received no response. This time, she decided to keep watch. She

climbed the stairs leading to the fourth floor and sat on one of the steps. From there, she waited to see who would exit his rooms.

At a little past nine, the key turned in the lock. To her surprise, two men emerged with their heads covered and walked rapidly away. From their clothes, she recognized them as Silas James, nicknamed "the General," and his cousin, Charles T. James. The pair were from Greenwich, Rhode Island, and had arrived by train in Worcester on February 25. They were boarding at the Waldo House on Waldo Street and had made the rounds of local saloons and gambling rooms. An acquaintance of the cousins had warned Clark that they were in Worcester to rob someone, but Clark had received many such warnings and took no notice.

Mrs. Eaton, remembering the warning, was now thoroughly alarmed. The door to Clark's rooms remained locked, so she broke a glass in the door window and let herself in. The room was full of smoke. She ran down the stairs and into the street to cry for help.

Two police officers soon arrived at the apartment. They hurried into the bedroom, where they made a grisly discovery. Clark lay on a bed, his head split open and a cord twisted violently around his neck. In an attempt to hide

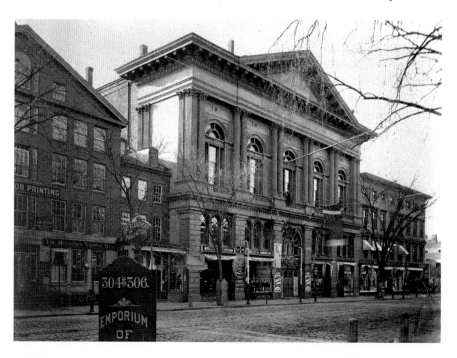

A GAR gala was underway in Mechanics Hall as the murder of Joseph G. Clark occurred next door. *LeBeau-Morrill Bullard Collection.*

evidence of their crime, his assailants had broken a kerosene lamp over his head, sprinkled the oil around and set the bed on fire.

City Marshal James M. Drennan, who was attending the event at Mechanics Hall, rushed to the apartment building. After talking with Mrs. Eaton, he immediately sent officers to the train station. There they found Silas James with two tickets to New York. There was no sign of his cousin, Charles.

Silas was arrested and taken into custody at ten o'clock, some three hours after the murder. He gave no resistance but denied any connection to the crime.

The next day, police arrested Charles James in Providence, Rhode Island. He had fled along the tracks from Worcester to the neighboring town of Westborough, where he hired a man to take him to Rhode Island. In his possession were a gold watch, a diamond ring and $1,000 stolen from Clark's room. During the trip back to Worcester, Charles confessed to the murder, something for which his cousin never forgave him.

According to Charles, Silas persuaded him to come to Worcester, saying that Clark had a large sum of money and would be an easy target. Charles admitted striking Clark with an axe as he was sitting in front of the stove and said that Silas put the rope around his neck to "stop his groaning." After carrying the victim into the next room and placing him on the bed, Silas robbed the body. Charles took away the axe, which the cousins had bought at a store on Main Street. He described the spot where he had thrown the axe into the Blackstone Canal as the two made their escape to the train station.

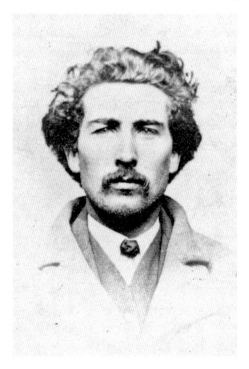

The next morning, police raked the canal under the viaduct on Front Street, and after a short search, they found the axe. With the murderers in custody and the weapon secured, the focus now shifted from investigation to prosecution.

Charles James led investigators to the murder weapon, which he had thrown into the Blackstone Canal near the Front Street viaduct. *Worcester Historical Museum.*

A SENSATIONAL TRIAL

The trial of Silas and Charles James was front-page news in Worcester not only because of the brutality of the crime but also because of the seamy underworld the murder exposed.

Worcester was a city in transition in the latter half of the nineteenth century. The opening of the Blackstone Canal in 1828 and the coming of the Worcester and Boston Railroad in 1835—later the Boston and Albany Railroad—had turned the city into a transportation hub. Manufacturing flourished, and massive mills were constructed, attracting thousands of immigrants from across Europe and parts of the Middle East. The city's population exploded—growing from 7,500 in 1840 to 41,100 in 1870.

Along with rapid growth came an expansion of criminal activity. The period after the Civil War was especially tumultuous, bringing an influx of thieves, con men and other miscreants to the booming city. Taverns and gambling houses thrived. Well-known gambling establishments of the time included the Brick House on Bloomingdale Road; Five Points Cottage near the Summit; Tatnuck Cottage, a short distance west of Newton Square; the Half-Way House, between Worcester and Millbury; the Farm, below Rice Square; and the White House on Belmont Street.

City Marshal Drennan, who had served three years with the Twenty-fifth Regiment during the Civil War, pledged to clean up the city, starting with a crusade against gamblers. This necessitated a bigger police force, which grew from twelve police officers in 1860 to thirty in 1870.

Silas James was well known to law enforcement but had never been convicted of a crime before the murder of Joseph G. Clark. *Worcester Historical Museum.*

The murder of Joseph G. Clark, one of the city's most notorious gamblers, and the

subsequent trial shone a light on the lawlessness that Drennan had promised to rein in.

Silas James, thirty-one, and his cousin Charles James, twenty-two, were arraigned for murder in the Supreme Judicial Court on May 18, 1868. Silas had been linked to many crimes in the past, including murder and arson, but he had always evaded prosecution. Charles had had little involvement with crime before coming under the influence of his older cousin.

The cousins were each assigned two attorneys to represent them. Each pleaded not guilty. Attorney George F. Verry, who represented Silas James, made a motion for a separate trial for his client on the grounds that an alleged confession had been made by one of the defendants that prejudiced the case of his client. The motion was denied, and the two defendants were tried together on June 10.

The evidence against them was overwhelming. The star witness was Clark's companion, Mrs. Eaton, whose real name was revealed to be Emma F. Thayer. A native of Charlton, Massachusetts, she was married but separated from her husband. She described her discovery of the crime and identified the Jameses as the men she saw leaving Clark's room.

Other witnesses included the store owner from whom the cousins had purchased the axe, the medical examiner, the city marshal, police officers, a longtime friend of Joseph Clark and a young man who was identified as Clark's son. A mysterious woman in black who attended the trial but did not testify aroused much curiosity. She turned out to be Clark's widow.

After the lawyers had rested their case, Chief Justice Reuben A. Chapman addressed the jury:

> *That Joseph G. Clark is dead, there is no doubt. How came he to his death? Not by suicide, or by disease, but he was murdered under extraordinary circumstances. He was murdered in his own room, in a triple manner, by hatchet, stone, and cord. The crime of arson was added to robbery and murder.*

Chapman reminded the jury that a witness had seen Silas and Charles James coming out of Clark's rooms, another had earlier seen them loitering around the building, that they had purchased the murder weapon and that neither defendant had offered an alibi for the time of the murder. The jury was out but a short time before returning a verdict of guilty. The defendants were sentenced to be hanged. Their attorneys filed appeals to commute the sentences to life imprisonment, but the motions were denied.

Execution was set for Friday, September 25, 1868. It would take place in the Summer Street Jail.

To the Gallows

For many years, hangings had been public spectacles that attracted huge crowds. But popular sentiment had turned against this practice. The last outdoor hanging in Worcester took place on December 7, 1825, when Horace Carter of Worcester was executed for the rape of an elderly Brookfield woman. After that, hangings were moved to the Summer Street Jail. The first person to be executed in the jail was Thomas Barrett of Lunenberg on January 3, 1845, for the murder of Ruth Houghton on February 18, 1844.

More than twenty years had passed without another execution when Silas and Charles James faced the gallows on September 25, 1868. The event excited a ghoulish fascination among the public. An announcement that the hanging would take place in the chapel of the jail drew heated protests from city ministers. Further interest was stirred by the revelation that the gallows used would be the same ones that had been used in 1850 to hang Harvard professor John White Webster for the murder of Boston businessman George Parkman, a notorious case that had held much of the nation enthralled.

Twelve official witnesses and thirty guests were allowed to view the hanging, but the *Gazette* noted that "many outsiders were possessed with a morbid desire to witness the dread scene, and as high as $500 had been offered by a sporting man for the required card." On the day of the execution, one hundred people waited outside the jail on the sidewalk in a torrential downpour, hoping to be among the first to receive details about the execution.

The *Gazette* did its best to give readers a sense of the condemned men's final hours:

> *THE LAST NIGHT ON EARTH.*
> *It was a dull, drizzly, dreary night. The rain came pattering down upon the jail roof, its dreariness strangely in sympathy with their condition. The little world in which they lived, assuming more of beauty as each hour passed by at almost lightning speed, was narrowly and surely contracting, and they took in the situation in all its fearful import. Charles retired to rest at 10 o'clock and slept quietly till 12 o'clock, when his rest was broken for three*

hours. Toward morning, he again enjoyed a season of quiet repose. Silas was out of his head during the entire night, and at 3 o'clock this morning, Dr. Rufus Woodward, the physician of the jail, was called. He remained with his patient until the time he went upon the scaffold. His sickness was doubtless caused by nervousness.

THE MORNING PREPARATIONS.
The morning was the same as the night. There was no sunrise. It was just one of those mornings when a miserable Frenchman would think of committing suicide. It was in truth a "hangman's day." The gray of the morning came on without the introduction of the sunlight, and the dripping of the rain was ceaselessly heard without their prison walls.

The prisoners rose early, washed and dressed themselves and ate breakfast—Silas "ate sparingly of food, while Charles partook heartily of what was set before him." They spent some time in prayer and meditation. Silas James received spiritual counsel from Reverend R.R. Shippen of Church of the Unity. Charles received the ordinance of baptism from Reverend Dr. William R. Huntington of All Saints' Church.

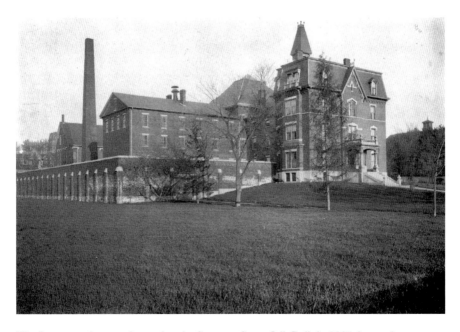

The James cousins were hanged at the Summer Street Jail. Built in 1835, it was the country's oldest working jail when it closed in 1972. *Worcester Historical Museum.*

At 10:27 a.m., Silas and Charles James were led from their cells to the gallows. The cousins did not exchange a word or a look. When the gallows was reached, Silas appeared calm. He thanked the officers for their kind and gentlemanly treatment, and as the rope was adjusted about his neck, he said, "Pull that rope tight, and give me all the drop you can."

Charles was visibly shaking. He prayed audibly and repeatedly, "Lord, be merciful upon me. Lord, help me." Some in attendance could be heard praying with him. When the prisoners' heads were covered, the sheriff announced that the preparations were complete. At his signal, the deputy sheriff sprang the drop at 10:42 a.m. The bodies fell about eight feet, tightening the rope over the pulleys with a sudden jerk, and the two Jameses hung suspended in midair.

Silas James died instantly, but Charles was slowly strangled to death. The *Gazette* described his final agonizing moments: "Charles struggled for at least three minutes, raising himself up and slackening the rope, so violent was his death; his body shook like an aspen leaf in the wind."

After the bodies had been hanging for thirty-one minutes, two doctors examined them and pronounced them dead. They were cut down and, at the family's request, "allowed to become cool before being prepared for interment." The following morning, the bodies were sent to West Greenwich, Rhode Island, where they received a Christian burial.

Only one more hanging took place in the Summer Street Jail, that of Samuel J. Frost of Petersham for the murder of his brother-in-law, Frank P. Towne, on May 25, 1876. After that, executions became a function of the state. Silas and Charles James thus retain the dubious distinction of being the only persons hanged in Worcester for a murder committed in Worcester.

GENTLEMAN GEORGE'S LAST HURRAH

Known for his daring burglaries across America, "Gentleman" George Ellwood's criminal career came to an end in Worcester in 1891.

As dawn broke over the city of Worcester on the late summer morning of September 10, 1891, a man in a slouch hat, dark frock coat and striped pants stepped off the 5:00 a.m. train at Union Station at Washington Square. About ten thousand passengers passed through the busy depot each day, so his arrival might have gone unnoticed except for a brief encounter with two police officers on Front Street. He asked if they could refer him to a doctor. Obligingly, they directed him to Dr. Dean S. Ellis in Franklin Square.

Dr. Ellis, seeing that his patient had a bullet wound in his back, had him sent to Worcester City Hospital. The patient gave his name as James Martin and claimed that he had been shot during a scuffle in a gambling room. The story seemed plausible, given the rough characters who frequented the gambling rooms that proliferated throughout the region at that time.

But Worcester police had received no reports of a gambling room shooting in the area. So an enterprising officer identified as Inspector Ames decided to pay the man a visit. His quick thinking would put an end to the criminal career of one of the most wanted men in America.

On the day Martin arrived in Worcester, local newspapers carried accounts of an attempted burglary in Hartford, Connecticut, the night before. A masked man had entered the home of L.T. Frisbie, going into his daughter's room and threatening to kill her if she didn't reveal the

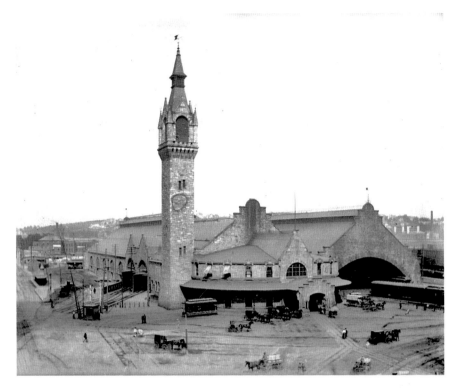

George Ellwood was among the ten thousand or so passengers who passed daily through Union Station, which was erected in 1875 and replaced in 1911. *LeBeau-Morrill Bullard Collection.*

whereabouts of the keys to her father's safe. She screamed, wakening her father, who immediately confronted the man. Frisbie was armed with a pistol and fired shots as the culprit made his escape.

A few nights earlier, a masked man had entered the residence of C.B. Humphrey in Providence, Rhode Island, and made off with diamonds and other valuables. There had been a similar masked burglary in Boston on September 2.

All these stories were fresh in Inspector Ames's mind as he approached the hospital bed of the man calling himself James Martin. A quick examination of his clothing revealed cash and jewels sewn into the lining. What's more, the inspector noted a resemblance to a description of an escaped convict that had been distributed to police departments several years ago: between thirty-five and forty years old, about five feet, nine inches tall and 180 pounds, with an "excellent physique" and a small scar on the left side of his head.

Ellwood was treated for a gunshot wound at Worcester City Hospital, which was opened on land donated by George Jaques in 1881. *LeBeau-Morrill Bullard Collection.*

Looking at the man in the hospital bed, the inspector had a strong suspicion that his real name was George Ellwood, a burglar widely known as "Gentleman George" who had escaped from an Ohio penitentiary in 1885. The city marshal put him under police surveillance while the wheels of justice were set in motion.

The next day, the *Worcester Telegram* carried the headlines:

> *Is He the Masked Burglar?*
> *Stranger Appears on Main Street with Fresh Bullet Wounds.*
> *He Claims to Have Received Them at a Gambling Table.*

As the city buzzed with excitement over the stranger's true identity, Worcester police began working with their counterparts in other cities. On September 12, the local paper reported:

The little heroine Florence Frisbie, with her father, will come to Worcester today to try and identify the prisoner. She did not see his face, as it was hidden by a long mask…with holes cut through it for eyes and nose, but she heard his voice and got a pretty good idea as to how big he is.

Humphrey joined the Frisbies in identifying "Martin" as the man who had broken into their homes, and Worcester police soon confirmed that the culprit was indeed "Gentleman George."

The Burglar Unmasked

The capture of Ellwood made national news. A native of Denver, Colorado, Ellwood had committed a string of masked burglaries across the country, generally at the point of a pistol. He was said to have murdered two of his associates in the earlier years of his career. In 1884, he robbed a residence in Toledo, Ohio, and in making his escape shot a police officer in the back. A year later, he was arrested in New York City, returned to Ohio and sentenced to ten years in prison. But after just a few years, he made a daring escape.

Reaching the roof of the penitentiary and going down through a shaft, he gained access to an officer's apartment. He put on the official's uniform and passed out of the prison yard, ready to resume his life of crime.

Now, thanks to the Worcester Police Department, Ellwood was about to be brought to justice again. On September 17, 1891, he was taken to Providence to face charges on the Humphrey crime. An article in the *New York Times* gave a detailed account of the journey:

Ellwood Surrendered.
He Jokes About His Burglarious Jobs and Appears Happy.

"Gentleman George Ellwood," the notorious burglar whose desperate criminal career was suddenly checked by two bullet wounds in the Frisbie residence in Hartford, and who was captured by the Worcester police, was brought to this city [Providence] *this forenoon…Ellwood is apparently in good physical condition, barring his wound, and on the trip to this city in the baggage car proved himself an agreeable companion, emphasizing his sobriquet "Gentlemen" George…Ellwood was cheerful and communicative,*

Ellwood's doctor's visit in Franklin Square in 1891, when the city's population had surged to almost eighty-five thousand, marked the end of his criminal career. *LeBeau-Morrill Bullard Collection.*

> *and…also sarcastically alluded to the harsh manner in which he was tossed about by the hospital and police authorities in Worcester. The bullet which penetrated the body near the heart has not been removed, nor has that in the back of the arm.*

After a vigorous legal battle in Providence, Ellwood was sentenced to twenty-five years in the penitentiary at Cranston. But that wasn't the end of his story. One of his prison mates was "Spike" Murphy, who had received a life sentence for killing Waterman Irons, a Providence businessman. The two men planned to escape. Ellwood armed himself with an iron bar, and when an opportunity presented itself, both men made a dash for liberty. The guards ordered them to stop, and Murphy threw up his hands. Ellwood reached the door but was shot dead by one of the guards.

Thus ended the notorious career of "Gentleman" George Ellwood.

CHAPTER 5

AXE MURDERER ON THE LOOSE

A hired hand was the only suspect in the triple slaying of Brookfield farmer Francis Newton, his wife and their daughter in 1898. Despite a nationwide manhunt, the suspect was never found.

Around eleven o'clock on the frigid Friday night of January 7, 1898, a young Brookfield resident named Arthur Rice was on his way home from a Grange meeting in North Brookfield. The twenty-one-year-old farmer had passed through Brookfield center, crossed over the train tracks and Quaboag River on the south side of town and was now traversing the broad expanse of flatland that preceded the left turn he would take to his home near Rice Corner Road.

As he traveled along the causeway, he passed a lone pedestrian heading in the opposite direction toward the train depot back in town. He recognized the man as Paul Mueller, a hired hand at the nearby Newton farm on the road to Sturbridge. Rice uttered a friendly greeting, but Mueller looked away, kept walking and didn't respond.

Mueller (whose last name was sometimes given as "Miller") was known to be of a brusque and solitary disposition, so Rice gave the matter little thought at the time. But he would soon have reason to remember that chance encounter. For Mueller, who was about to become the object of a nationwide manhunt, was fleeing the scene of the brutal slaying of the entire Newton family.

Rice was the last person to positively identify Mueller before the man effectively vanished from the face of the earth.

"THREE DEAD IN THEIR HOME"

Newspapers around the country carried the story of the Newton murders, complete with lurid—and often conflicting—details. However, the bare facts of the tragedy are fairly straightforward.

Francis D. Newton, born in 1850, was the son of Peter and Catherine (Wheelock) Newton of New Braintree. In 1876, he married twenty-year-old Sarah Walker of North Brookfield, daughter of Joseph L. and Charlotte (Holmes) Walker. The couple lived with their adopted daughter, Elsie, born in 1887, on a prosperous farm about three miles south of Brookfield center.

Brookfield, with a population of about three thousand, was a bustling community in the late nineteenth century. Its outlying areas were primarily devoted to farming, but its small center housed a barber, a dentist, a haberdasher, a jeweler, a milliner, three grocery stores, four churches and three hotels, including the Brookfield Inn, which was famous for turning away George Washington during his tour of New England shortly after becoming the nation's first president.

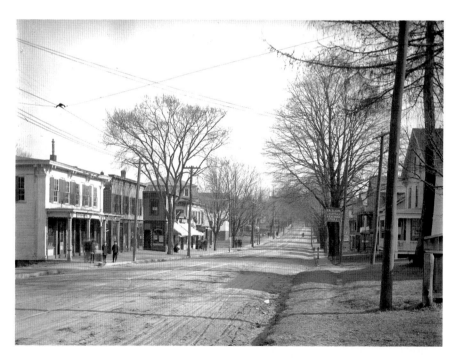

The Newtons knew Brookfield as a thriving community with a lively commercial district and several busy factories. *LeBeau-Morrill Bullard Collection.*

Several mills also thrived in Brookfield, including the G.H. Burt & Company boot and shoe factory on Central Street and the A.L. Twichell & Company heel factory west of Lower River Street. The Boston and Albany Railroad connected Brookfield to the wider world, while a new trolley system provided transportation to nearby communities.

The Newton house—built by Merrick Rice in 1805—was a spacious Federal-style colonial with a chimney at either end and a long, covered front porch. The property was set on a hillside that afforded a pleasant view of Quaboag Pond—then called Podunk Pond—in the distance.

Two or three months before the murder, Francis Newton had hired a farm hand by the name of Paul Mueller. Mueller was in his mid-thirties or mid-forties, with a compact build, black hair and mustache and dark eyes. He had previously worked for H.D. Hodgston at Point of Pines, a hotel and recreation area on the current site of Camp Frank O. Day on South Pond and, before that, at a hotel in Holland, Massachusetts.

On the day of the murders, Newton and Mueller had gone to Worcester to buy a horse but had returned to the farm without making the purchase. At some point that night, most likely between ten and eleven o'clock, Mueller bludgeoned the Newton family with an axe as they lay sleeping in their beds—Sarah and Elsie in a first-floor bedroom and Francis in his chamber on the second floor.

After ransacking the house for money and other valuables, and after making a clumsy attempt to cover up his crime by starting a fire, he made his escape. The victims lay undisturbed in their blood-soaked beds as dawn broke. The stoves went cold, and the long, bleak day faded into another frigid night. Two days went by. The silent house concealed its awful secret.

Then, on Monday, January 10, Arthur Rice, who had encountered the Newtons' handyman on Friday night, happened to pass by the Newton farm. He heard the sound of cattle lowing in great distress. Seeing no sign of activity on the premises, he became curious and soon discovered that the animals had not been milked for a few days. Suspecting that something was wrong, he knocked on the house door. There was no response.

Rice then let himself into the house through an unlocked window. He was immediately hit by a powerful stench of carnage. Nevertheless, he lit a lamp and began to investigate. In the downstairs bedroom, he found the mutilated bodies of forty-one-year-old Sarah and eleven-year-old Elsie. The walls and ceiling were splattered with blood.

He rushed from the room and tripped over a bloodied axe on the hall floor. Steeling himself for what he might find upstairs, Rice proceeded to the

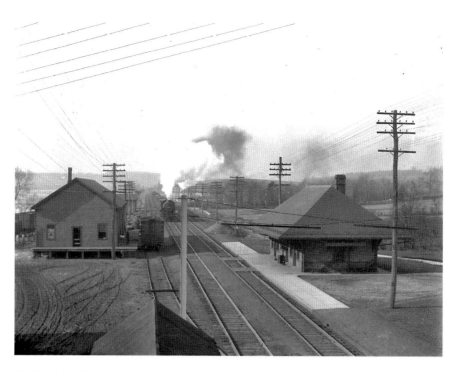

On the night of the murders, Arthur Rice saw Paul Mueller heading toward the Brookfield train depot, where seven passenger trains stopped daily. *LeBeau-Morrill Bullard Collection.*

second floor. There, in a blood-soaked bedroom, he discovered the similarly mutilated body of forty-nine-year-old Francis Newton.

Rice hurried away to alert authorities. The police and medical examiners quickly determined that the Newtons had indeed been murdered, that the axe in the hallway was almost certainly the murder weapon and that robbery was most likely the motive. Furthermore, they found that the floor of an attached shed had been soaked with kerosene and that a candle had been lit with the apparent intention of causing a fire, probably to conceal the crime.

The obvious suspect was Paul Mueller, who had not been seen since the estimated time of the murder on Friday night. The police wired alerts to police departments near and far, launching a nationwide manhunt for Mueller. The grisly story made headlines across the country.

The *New Haven Evening Register* announced, "Three Dead in Their Home. Horrible Triple Tragedy in Brookfield, Worcester County, Mass. Murders Were Done with an Axe." The *Idaho Daily Statesman* in Boise screamed, "Brained with an Axe." The *Philadelphia Inquirer* featured the headline,

"Mysterious Murder of a Whole Family. Father, Mother and Child Are Chopped to Death with an Axe."

Meanwhile, as the gruesome news spread across the country and as the search for the murderer intensified, the Newtons' family and friends were left to deal with the sad aftermath of the tragedy.

ALL FLESH IS GRASS

The day after the murders were discovered, a funeral service was held in the Newton home. Mourners began arriving at ten o'clock in the morning. Almost one hundred carriages and teams filled the yard and fields. Inside the house, the bodies lay in the front room to the right of the center hallway. Francis and Sarah's caskets were draped in black. Elsie lay in a white casket. Family members were seated in the room to the left of the hallway. Throngs of mourners stood on the staircase, on the porch and in the yard.

Sumner Holmes of North Brookfield conducted the funeral. At two o'clock in the afternoon, Reverend E.B. Blanchard of the Congregational Church stood in the hallway to deliver the sermon. He did not mention the murders, instead choosing as his theme a verse from Isaiah: "All flesh is grass, and all goodliness thereof is as the flower of the field…We are like grass which springeth up to die again, but the word of the lord endureth forever." There was no singing or music of any kind.

Sarah's parents were there—Francis's parents had predeceased him—as was Elsie's mother, Mrs. Jennie Benson. She had come from Natick, where she lived with her husband and two boys, ages eight and four. She wept copiously over her lost daughter and expressed gratitude to a family member who gave her a photo of the child as an infant.

When it was over, the bodies were taken to the receiving tomb in the Brookfield cemetery to wait until spring for interment in a Newton family plot in the cemetery on Webb Road in New Braintree.

One month later, administrators of the Newton estate held an auction, noting that "the question of the rightful inheritance will be decided by the probate court later." Sumner Holmes of North Brookfield represented the heirs of Sarah Newton, Timothy Howard of North Brookfield represented the heirs of Elsie Newton and Deputy Sheriff W.E. Tarbell of East Brookfield represented the heirs of Francis Newton. The property offered for sale included "a horse; four cows, 2 in milk, four two-year-olds; two yearlings,

Reverend Blanchard of the Brookfield Congregational Church delivered the funeral sermon in the Newtons' home. *LeBeau-Morrill Bullard Collection.*

two shoats; 75 hens, farm wagon, express wagon, Concord buggy, farming tools, household furniture, five tons of good English hay, ensilage, etc."

The auction attracted a good crowd. But the tragedy—and the specter of the missing farmhand—must have cast a shadow over the proceedings. So far, the search for Paul Mueller had turned up nothing but false leads.

The Elusive Killer

In the aftermath of the Newton tragedy, newspapers featured conflicting accounts of the murder and numerous reports of false sightings of the suspect. Early on, robbery was thought to have been the motive, as "the house was in great disorder, bureau drawers having been ransacked and their contents scattered about the rooms," according to the *Register*.

Lending credence to the robbery theory was the fact that Francis Newton's purse was empty despite the fact that he had likely possessed cash when he tried, unsuccessfully, to buy a horse on the morning of the murders. However, neighbors said that Newton normally kept very little money in the house. Furthermore, his gold watch was still in the pocket of a vest that was hanging over the back of a chair in his room. And robbery didn't explain the murder of the entire family.

Soon, another theory emerged, that Mueller's motive had been revenge. According to Hodgston, his former employer, Mueller was given to fits of rage and was cruel to the animals in his care. Afraid to fire him for fear of retribution, Hodgston had been relieved when Mueller went to work for Newton.

Neighbors reported that Newton had recently berated Mueller for not feeding the animals until three o'clock in the afternoon, leading some to believe that he killed Newton out of anger and killed the women so they couldn't identify him. Or perhaps he bore a grudge against all of them.

Further confusing the story, one newspaper reported that a bottle of laudanum had been found on the floor of the women's room. The article suggested that all three may have been drugged, which would explain how they were all killed in their beds. It did not suggest how they had come to ingest the drug.

None of the theories was entirely satisfactory, and none could be proven by anyone other than the perpetrator himself. Mysteries about the motive remained, as did mysteries about the Newtons' hired hand. Paul Mueller was identified as a "foreigner," variously described as Polish, Bohemian or German. He was said to have served in the German army, but a newspaper article found in his room led investigators to suspect that he may have been an escaped convict. The article described the escape of nine convicts from a Springfield, Massachusetts prison in 1892. None of the escapees was named "Mueller" or "Miller," but the hired hand may have been using an assumed name.

False reports about his whereabouts sprang up almost immediately after the murders. A man fitting his description had reportedly been

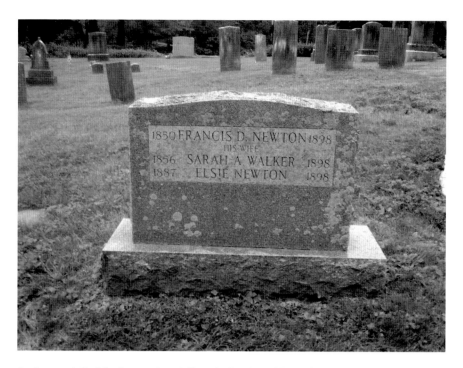

As the search for Mueller continued, Francis, Sarah and Elsie Newton were buried on April 12, 1898, alongside his parents in New Braintree. *Author's collection.*

seen in West Brookfield buying a train ticket to New York. But tickets to New York were not available in West Brookfield, so the informant's story was suspect.

On January 13, the *Idaho Daily Statesman* carried a story stating that Mueller was believed to be California murderer James C. Dunham, who had murdered six people with an axe. The story claimed that descriptions of the two men closely matched and that detectives had traced Dunham to Boston before losing track of him. Nothing came of that lead.

On January 21, the *New Haven Register* reported that Sheriff Tarbell had gone to Westerly, Rhode Island, to see a man being held by police on suspicion of being Mueller. Tarbell said that although there was a resemblance, the man in custody was not Mueller.

Soon, local papers announced another lead in the Newton murder case, this one coming from Lansford in the coal mining region of Pennsylvania. But after Brookfield police received a "complete description and photograph" of the suspect, they determined that he was not their man.

On February 22, 1898, the *Brookfield Times* carried the following story:

> *Ex-Gov. D.H. Chamberlain, who is much interested in the Newton murder and who would like very much to have Mueller, the suspected murderer, captured and has offered $100 reward for his capture, while in New York last week had an interview in regard the matter with Mr. Pinkerton of the detective agency. Mr. Pinkerton does not think that a larger reward would hasten Mueller's capture. He is of the opinion that if he is ever caught it will be accident, as by this time he is in some place of safety.*

Pinkerton may have been right. The next reported sighting of Mueller came about as the result of a strange coincidence. Joseph Olds, who had lived near the Newton farm, had enlisted during the Spanish-American War in 1898 and was discharged in California in 1900. He took a job in Portland, Oregon, where he saw a man he believed to be Newton's handyman. Olds notified Portland police, who detained the man. A photograph was mailed to Brookfield, where police confirmed that the suspect was Mueller. They wired Portland, but a severe storm had knocked down telegraph lines. Portland police, receiving no word from Brookfield, released the suspect.

There is no way to know for sure if the man in custody was indeed Mueller or if he was simply someone who closely resembled him. Years passed with no further reported sightings until August 1906, almost eight years after the murders, when the *Brookfield Times* reported another disappointing lead:

> *Another "suspect" in the Newton murder case was found in Enfield, this week. Deputy Sheriff Tarbell, Detective Peleg F. Murray and Arthur Rice of Brookfield looked him over at a blacksmith shop where he was employed, but decided he was not the much-wanted man.*

It was the last such sighting to be recorded. Paul Mueller, or Miller, or whoever he was, had simply vanished.

Gradually, the Newton tragedy became part of local lore. Details of the murder faded away. What people remembered, when they thought about the Newtons at all, was that a loving, decent family had perished in a senseless act of violence.

TRIPLE SUICIDE OR SINISTER PLOT?

The suicide of bridegroom-to-be Henry Hammond in 1899 was the first death in a strange string of tragedies that have mystified Spencer residents for more than a century.

Everyone loves a good mystery story, and none has captured the imagination of Spencer residents quite as much as the Prouty-Hammond tragedy. The deaths that occurred in January 1899 and the strange sequence of events that followed have led to recurring speculations that a sinister plot or supernatural forces may have been at work. The truth of the matter will never be known, as the major players in the drama are long gone. But curiosity remains, as do theories about what led to the calamity that struck two of Spencer's most prominent families.

At the close of the nineteenth century, Spencer, located about thirteen miles west of Worcester, was a prosperous community with a thriving dairy industry, numerous boot and shoe factories and a booming network of wire mills. With a population of about 7,600 in 1899, the town was the beneficiary of several philanthropic industrialists who donated some of the community's most impressive public buildings as well as a public park. The industrialists built grand houses for themselves near the bustling commercial center, which was filled with stores and small businesses that attracted customers from many of the surrounding towns.

It was in this lively and flourishing community that what came to be known as the Prouty-Hammond tragedy unfolded. On the Friday morning of January 6, 1899, twenty-three-year-old Henry Hammond—due to be

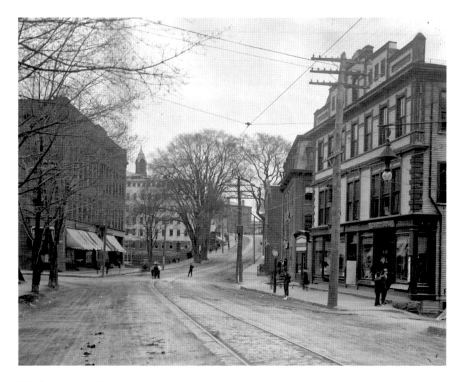

The Prouty and Hammond families were among the business leaders who spurred Spencer's prosperity, evident in the many businesses that lined Main Street. *LeBeau-Morrill Bullard Collection.*

wed in just four days—rose at five o'clock, as was his custom, and went to the barn in the rear of the family mansion at 27 High Street. There, he joined his father, Aaron Hammond, in caring for their horses. It was a morning ritual that seldom varied. When their work in the barn was done, the men returned to the house and sat in the kitchen while the housekeeper, Margaret Johnson, prepared breakfast.

The meal was soon ready, and father and son headed to the dining room. Henry first made a detour to the library, which was not unusual, and the elder Hammond expected his son to join him shortly. When the young man didn't appear, Johnson went to the library to fetch him. She found Henry on his back on the floor, his face covered with blood. She cried out that Henry had fallen and hurt himself.

Aaron Hammond rushed to the library. He saw that his son had suffered a bullet wound in the forehead. A revolver lay between his legs. In the quiet house, no one had heard the shot—not even a cousin who was sleeping in a

room directly overhead. Dr. Ephraim Norwood, who was also the medical examiner, was urgently summoned. But Henry was beyond help, and his death was ruled a suicide.

The revolver Henry used had been in the family for almost twenty years. To his father's knowledge, it had never been loaded. But after the death, a note in Henry's handwriting was found in the desk drawer where the gun was kept. It read, "Loaded! Do not handle." It looked as if Henry had planned his suicide in advance. He had loaded the weapon, returned it to the drawer and written a cautionary note to ensure that no one was accidently injured before he followed through on his desperate plan.

EVERYTHING TO LIVE FOR

The suicide stunned Henry Hammond's family and friends and perplexed the wider community. He was a young man with seemingly everything to live for. The beloved only child of Aaron and Ida (Swan) Hammond, Henry possessed good looks, good health and good fortune. As the *Worcester Telegram* wrote on the morning after his death, "He had everything that makes life worth living—loving, indulgent parents, youth, health, wealth, an assured social position, and a fond sweetheart, soon to be his wife."

Henry's father, the son of a Charlton farmer, was a shrewd businessman who had risen from being a clerk in a Worcester retail market to being the sole owner. Aaron Hammond also invested in real estate, owned two Worcester business blocks and ran a wholesale provision business and cold storage plant on Wall Street in Spencer.

The family lived on Main Street in Worcester until 1892, when Hammond purchased one of two twin mansions at the top of High Street in Spencer. The houses were built by Lewis and George P. Prouty, sons of Isaac Prouty, who had founded the Prouty Boot and Shoe Company, which dominated the center of town for decades. Lewis died of pneumonia while his house was under construction, and Hammond bought the property.

Henry had attended Becker Business College and was employed as chief clerk in his father's cold storage business. He led a quiet but pleasant life, indulging his passion for horses and enjoying the companionship of a small circle of friends. His fiancée was twenty-year-old Iris G. Prouty, the elder of two daughters of Maria (Peel) and William H. Prouty. William, along with two brothers, owned the Prouty Brothers boot manufactory

Aaron Hammond purchased one of twin mansions built by sons of Isaac Prouty, who founded the massive shoe shop that dominated the town center. *LeBeau-Morrill Bullard Collection.*

at 120 Main Street—a smaller shop than that of his distant relatives but profitable nevertheless.

William had built a fine home at 11 Ash Street in 1882, and it was there that the wedding was set to take place at six in the evening of January 10. From all accounts, Henry had appeared to look forward to the marriage. He had happily discussed wedding plans with his mother and devoted many hours to looking over railroad schedules in preparation for his honeymoon tour. His clothes for the trip were carefully packed in traveling bags in his room. The day before his death, he and Iris had been out riding together, and later that evening, he had visited her at her home. Both families were pleased about the match, and his father had made financial arrangements to ensure a comfortable life for the young couple.

There seemed to be no rational explanation for Henry's act and no warning of his intent. The housekeeper, who had been with the family for fifteen years, later stated that he had been pale and uncommunicative when he left his room that morning, as if he had had a troubled night. Her memory may have been colored by the subsequent event, or Henry may indeed have spent his last night on earth in mental anguish.

Whatever his state of mind, his sudden death plunged his parents and fiancée into grief. His father was quoted in the *Worcester Telegram*: "He was

all his mother and I had to live for and we are left desolate now." Albert L. Nichols, a close friend of Henry's who was employed at Hammond's cold storage plant, was also deeply affected. He was at work when he received the news and became so distraught that he almost collapsed.

In the midst of this tragedy—as wedding plans turned to funeral plans for Henry Hammond—another suicide struck the families involved and shocked the entire community.

Strangled by Her Own Hand

The day after Henry's death, Iris Prouty's mother, Maria, spent the afternoon at the Hammond home to offer support to her daughter and to the young man's grieving parents. Iris planned to stay with the Hammonds until after Henry's funeral, which was set for January 8, two days after his death.

Maria returned home to an empty house. There, she climbed the stairs to the attic, tied a silk handkerchief around her neck and ended her life. Maria, who was fifty years old, had withdrawn from society some years earlier. She suffered from neuralgia, which caused sudden painful attacks, and had grown so depressed that she rarely left her house. Her life revolved around her daughters, Iris and Louise, and her husband. Louise was away at Wellesley College, and her husband had recently accepted a job in Boston that would keep him away from home for extended lengths of time.

This combination of circumstances had deepened Maria's depression, although her spirits had brightened during preparations for Iris's wedding. Upon learning of her future son-in-law's death, she had completely broken down. But the next day, January 7, she appeared to have regained her composure. Certainly, she rallied enough to visit the house of mourning. She gave no hint of her desperate intent when she bid her daughter farewell for the final time.

William Prouty returned home from work at about 4:30 p.m. Seeing no sign of his wife, he searched the house. He found her in the attic, dead or near death with a handkerchief around her neck. He called his brother, Fields M. Prouty, from his nearby home on Cherry Street. Fields—who had been married to Maria's sister until her death some years earlier—summoned the family doctor, Ephraim Norwood, who tried to resuscitate Maria without success. Norwood listed the cause of death as suicide by strangulation.

Maria Prouty's life revolved around her husband and daughters. Iris is seen here at the age of seven months. *Jim Condy.*

Henry's funeral was held on January 8 at his parents' home on High Street, which was filled to overflowing. Iris Prouty, who had lost her betrothed and mother in a span of two days, was among the mourners who attended the service. He was buried at Hope Cemetery in Worcester.

The following day, Maria Prouty's funeral took place in her family's Ash Street home. The service was private, attended only by members of the immediate family as well as Ida and Aaron Hammond. She was buried at the Pine Grove Cemetery in Spencer.

Maria's death by suicide, coming as it did the day after her future son-in-law's, fueled wild rumors of adultery, murder and coverup. Some newspapers reported on the rumors, featuring such dramatic headlines as "Spencer's Harvest of Death." The sensational stories led the *Spencer Sun*, on January 14, 1899, to scold Worcester and Boston reporters who "embellished rumors which they knew must be absolutely untrue and without any foundation in fact."

Amid the rumors, the Hammond and Prouty families maintained a dignified silence. Time passed, rumors faded and life resumed an air of normalcy—as normal as is possible, at any rate, for people who have endured unspeakable tragedy. Then, in 1902, the suicide of Henry Hammond's close friend Albert Nichols raised the specter of those earlier deaths.

Another Suicide

Albert lived with his wife, Hattie (Preston) Nichols, and their five children in East Brookfield. The son of Austin and Josephine (Bond) Nichols, Albert was a bookkeeper at Aaron Hammond's cold storage plant. His managerial skills were such that Hammond left much of the management of the facility in his capable hands.

Albert was eight years older than Henry and had formed a close bond with the younger man. When Henry died, he was "almost prostrated with the news." Time did not heal the wound. He frequently spoke of his friendship with Henry, often weeping as he did so.

In the months prior to his death, Albert's depression had deepened. Some attributed it to health problems, citing a particularly severe bout of hay fever the previous summer or a vaccination he had received. His doctors were puzzled and dismissed the notion that his deteriorating health was in any way related to the inoculation.

Three weeks before his suicide, he had been unable to go to work. He spent days in bed, incapacitated by despondence. Friends recommended that he go to his parents' home to rest in quiet, away from his young children. He took their advice, moving into his childhood home on Main Street in East Brookfield, just east of Gleason Avenue. But his depression continued to deepen. He stayed in his room, where his parents frequently found him crying inconsolably.

On the evening of April 10, 1902, a little more than three years after Henry's suicide, his mother heard him fall in a first-floor room off the dining room. She hurried through the house and found her son lying facedown on the floor. Blood gushed from a wound on his neck. He had taken a straight razor from a bureau drawer and, standing in front of a mirror, slashed his throat. His windpipe and jugular vein were severed.

Dr. William F. Hayward was quickly summoned and pronounced him dead. Dr. Norwood, the medical examiner, arrived soon after. He declared the death a suicide.

Albert Nichols was the final victim in the tragedy that began in January 1899. The survivors carried on with their lives as best they could. The Hammonds and the Proutys were occasionally mentioned in the local press. Aaron Hammond and Lewis T. Bemis made a tour of the West in September 1900. In 1904, the Hammonds spent Christmas with relatives in Charlton. Aaron Hammond died while working in his barn in 1911. His wife passed away in 1917. Their mansion was torn down in 1919, and

a new house erected on the lot. Like their son, the Hammonds were laid to rest at Hope Cemetery.

William Prouty moved to Boston soon after his wife's death and sold the house on Ash Street in 1903. His daughter Louise became a librarian at the Harvard Library and lived with him until his death in 1910. Iris lived with him for a while before embarking on a notable career in education.

She received teacher training at Columbia and New York Universities and was affiliated with the First Pennsylvania Normal School, the New Bedford Industrial School and the Vocational Department of Education at Newark, New Jersey. She wrote several training manuals for the U.S. Bureau of Education—some of which are available online—and married Wesley A. O'Leary.

Over time, the suicides of three prominent people might have faded from public memory were it not for that rash of early rumors and a writer calling himself Gerard Lind. In 1941, Lind resurrected and further sensationalized the rumors in a *True Detective* magazine article titled "The Sinister Halo." In it, he theorized that a diabolical plot or supernatural curse had affected all who had been involved with the tragedies.

PERSISTENT RUMORS

The death of Henry Hammond raised questions from the start. Why would someone with so much to live for choose to end his own life? At first, newspaper articles suggested that a personality flaw was to blame. On January 7, 1899, the *Spencer Sun* wrote, "His was a modest and retiring nature, however, and he shrank greatly from publicity. His most intimate friends philosophize that he worried over the publicity which his wedding might attract until it affected his reason."

The *Worcester Telegram* featured the headline, "Too Timid to Marry, Lad Shoots Himself! Only Explanation Found for the Suicide of Henry Hammond of Spencer." The article noted, "His only failing was his overwhelming bashfulness. He was painfully diffident…Being an only child, his every wish had been indulged, and he grew to manhood more retiring in his nature than most young men."

With the death of Maria Prouty, the speculations grew darker. Her manner of death was in itself puzzling. How likely was it that anyone—especially someone as physically frail as Maria Prouty—would have had the strength

to strangle herself? Even the *Spencer Sun*, which maintained a discreet and respectful tone throughout the affair, delicately questioned the stated manner of death: "The medical examiner and the family gave out the statement that death was due to strangulation. Whether this was accomplished by the aid of the handkerchief or other means is not made known."

The absence of details created an information vacuum that filled with a flood of rumors. It was whispered that there was more to the story than was being made known. One early and persistent rumor was that Aaron Hammond and Maria Prouty had had an affair many years ago and that Iris was Henry's half-sister. According to this theory, just days before the wedding was set to take place, Aaron Hammond told his son the truth of Iris's paternity and demanded that he back out of the marriage. Henry was so distraught by the revelation that he took his own life. Then, fearing scandal if the truth came out, Maria also committed suicide.

Another rumor was that Maria had been murdered, possibly by Hammond to prevent her from revealing their affair. Some went so far as to claim that Henry may have died at his father's hands.

There was no evidence to support any of the rumors, but that didn't prevent Gerard Lind from repeating and embellishing them more than forty years later. In "The Sinister Halo," he manipulated facts and invented details to weave an intricate and macabre tale.

To set the stage, he claimed that Henry and Maria had died on the same day, Friday, January 6. Creating a "Black Friday" motif, he said that Albert Nichols died the following Friday, January 13, 1899. Then, he added to his tale the unrelated suicide of a wire mill worker named Charles Demers on Friday, January 20, claiming that the man had been offered a job by Aaron Hammond and had since been so troubled by "visitations" from Henry that he took his own life—the "third Friday in succession to be marked by a death of violence at 6 a.m.," according to Lind. (Charles Demers did indeed commit suicide on that day, but he had no known connection to Aaron Hammond.)

Having thus established an appropriately ominous tone, Lind described mysteriously missing letters, waylaid telegrams, overheard shouting matches and secret conversations—all suggesting that something extraordinarily evil was afoot. But four deaths by suicide were not enough for his purpose. Lind proceeded to connect a string of violent or untimely deaths to the Prouty-Hammond mystery. Most of the deaths he described occurred from twenty to thirty-eight years after the fact, and the victims had little, if any, connection to the Hammonds or the Proutys. But Lind blithely changed dates and invented connections where none existed.

A sampling of his list of victims includes:

- *John Taylor of Boston, supposedly a salesman for Hammond, found dead in a Worcester rooming house with his throat slashed.*
- *Francis Berry, formerly of Spencer and supposedly a former employee of Hammond, found "stabbed in throat and chest, head battered, skull smashed" on railroad tracks in Pass Christian, Mississippi.*
- *James Harrington, a Spencer jeweler supposedly commissioned by Henry to make the wedding rings, found dead of a self-inflicted gunshot wound in the back room of his store.*
- *Harris Dodge, who supposedly provided information to investigators about Aaron Hammond's assignations in Charlton with a mysterious veiled woman in the 1870s, found dead of a self-inflicted gunshot wound.*
- Worcester Telegram *publisher Austin Cristy, who supposedly backed off from running an expose of the Prouty-Hammond mystery, found dead of self-inflicted gunshot wound.*
- *Lewis Dunton, supposedly to have been best man at Henry's wedding, found dead of carbon monoxide poisoning thirty-six years to the day after Henry's death.*

And on it went. To this litany of bloody deaths, Lind added the claim that Maria Prouty had almost certainly been murdered. Investigators, he said, had found slivers of wood on her face and hands and a deep bruise between her shoulder blades, suggesting that someone had pushed her onto the attic floor, held her down and strangled her. Spencer's most powerful citizens, he suggested, had forced investigators to conceal the truth.

Despite his lengthy and colorful story, Lind failed to present convincing evidence for his claims. Nor did he attempt to clarify who or what was behind the tragedies. Instead, he left his readers with a series of provocative questions: "Was there really an evil spirit at work? Was it all the strangest, longest chain of circumstance that ever wove the destiny of men? Or was there…an evil secret at the depth of the whole tragic story that brought destruction and death with its knowledge?"

The story made thrilling reading, one that has been periodically resurrected in one form or another over the years. But most of it was fiction, and it did little to solve the mystery of why three people with seemingly so much to live for had chosen to take their own lives.

In the case of Maria Prouty, we can perhaps surmise that her long-standing depression was deepened by the shocking death of her future son-

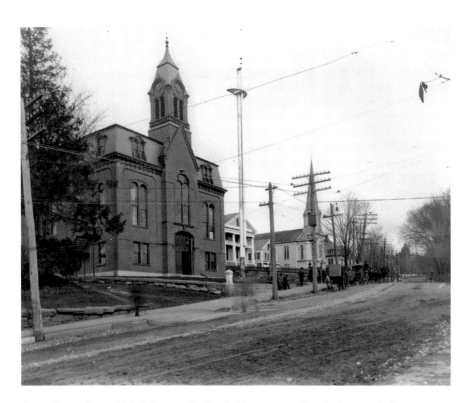

According to Gerard Lind, Spencer leaders held secret meetings in the town hall to cover up the truth behind the Prouty-Hammond tragedy. *LeBeau-Morrill Bullard Collection.*

in-law. Consequently, she may have fallen prey to the phenomenon known as "copycat suicide," in which an emotionally unstable person emulates the self-destructive actions of another. And while her method of suicide remains mysterious, respect for the family and a sense of discretion likely prevented the medical examiner from releasing more intimate details of her death.

The suicides of Henry Hammond and Albert Nichols are more puzzling. After all, Henry had exhibited no obvious signs of depression, and Albert had had three years in which to heal from the trauma of his friend's death—all of which raises the question of the exact nature of their relationship. By all accounts, the two men were extraordinarily close. Albert was said to have been something of a mentor to the younger man. But was there more than that between them?

On January 7, the day after Henry's death, the *Worcester Telegram* carried a lengthy article about the tragedy. It included the following statement: "Henry had always expressed repugnance at the bare mention of suicide,

and lately had a discussion with Albert L. Nichols of East Brookfield, clerk for Aaron Hammond."

Why had they discussed suicide? Had Henry confessed his unhappiness to Albert? If so, what was the cause of his discontent? Was it possible that the men felt a romantic attraction to each other that, because of their social standing and the times in which they lived, had to be kept hidden? Did one suffer from unrequited love for the other? Did they share some shameful secret?

Whatever the truth of the matter, Albert never recovered from Henry's death. All that can be said with certainty is that Henry Hammond, Maria Prouty and Albert Nichols took their secrets to the grave.

MAJOR LEAGUE NIGHTMARE

Beset by mental illness, Major League Baseball star Martin Bergen murdered his family and then took his own life in North Brookfield in 1900.

On the bleak Saturday morning of January 20, 1900, three horse-drawn hearses made a slow procession through the icy streets of North Brookfield, Massachusetts. The heavy *clomp* of the horses' hoofs beat a somber rhythm to the steady drum of freezing rain.

Their destination was St. Joseph's Church, a modest white clapboard structure on Main Street where the family within the caskets had worshipped regularly. Twenty-eight-year-old baseball star Martin Bergen and his wife, thirty-one-year-old Hattie (Gaines) Bergen, lay in separate caskets. Their two children, six-year-old Florence and three-year-old Joseph, lay side by side in a single oblong box.

About eight hundred mourners stood in the gloom outside the church. Nearly as many were crowded inside, hoping to draw some comfort from the sermon of Father James Tuite—the same Father Tuite on whose team of altar boys a young Martin had discovered the talent that would take him to the top of the National League.

The small town of farmers, millworkers and shopkeepers was reeling from the tragedy that had befallen the Bergen family, a tragedy so horrific that it defied human understanding. It most certainly defied the usual paths of sane reasoning.

And therein lay the problem. For Martin Bergen was not sane. Despite his spectacular success on the ball field and his well-known love for his family, he was hounded by anxiety, depression, paranoia, hallucinations and rage. Today, he would most likely be treated for schizophrenia and other mental disorders. But in Martin's time, effective treatment lay far in the future. Instead, he grappled with his demons as best he could, alienating teammates, mystifying fans and frightening many who came in contact with him.

And in the frigid early morning of January 19, 1900, he took an axe to the people he loved best in the whole world. Then he slit his own throat.

BORN TO PLAY BALL

Martin Bergen was born in North Brookfield, about eighteen miles west of Worcester, on October 25, 1871. One of six children raised by Michael and Ann (Delaney) Bergen, who had emigrated from Ireland in 1865, Martin grew up in a town that had been transformed by shoe manufacturing. Largely agricultural until Oliver Ward built the town's first shoe factory in 1810, North Brookfield by the late 1800s was home to the largest shoe factory in the country—E. & A.H. Batcheller Boot and Shoe—as well as smaller shops, including Dewing & Edmands and Edmund Smith. Martin's own father supported his family by working in a shoe shop.

As the town prospered, the population grew—from 3,300 in 1870 to 4,600 in 1900—bolstered by an influx of primarily Irish and French Canadian immigrants. Farming and small businesses flourished. The social calendar was enlivened by dances, musical recitals, public orations and church suppers. By the 1880s, as Martin entered his teenage years, a new national pastime had captured the imagination of the thriving community.

Informal baseball had been around for decades, but professional baseball was beginning to flower as Martin was coming of age. The Worcester Ruby Legs, one of the first teams in the nascent National League, thrilled audiences at their home games just up the road at the Worcester Agricultural Fairgrounds. It was there, on June 12, 1880, that baseball's first recorded perfect game was pitched by Lee Richmond against the Cleveland Blues.

Farther up the road in Boston, the Boston Red Caps—later the Boston Beaneaters and then the Boston Braves—had played in the first game in the history of the National League on April 22, 1876, when they defeated the Philadelphia Athletics, 6–5. They went on to win league pennants in '77,

Martin Bergen was a hometown hero in North Brookfield, where baseball was a passion. Note the boys holding baseball gear in this school photo. *LeBeau-Morrill Bullard Collection.*

'78, '83, '91, '92 and '93, establishing themselves as one of the best teams in what was then the only league in the majors.

Martin and his younger brother, William, loved the game. They devoted endless hours to perfecting their skills. Both were catchers, and while both would make it to the majors—William played for eleven years and Martin for four—Martin's natural athleticism and feel for the game made him the better player. Future Hall of Famer Jesse Burkette told the *Worcester Spy* in 1900:

> *As a catcher, Martin Bergen was the best the world ever produced. No man acted with more natural grace as a ballplayer. There was finish in every move he made. His eye was always true and his movements so quick and accurate in throwing that the speediest base runners…never took chances when Bergen was behind the bat.*

Yet even as a kid, his talent conflicted disturbingly with his volatile mood swings. He was touchy and given to tantrums, sometimes throwing down his

gear and stalking off the field in a fit of anger. The pattern of unpredictability followed him into the minor league, where he moved from team to team, exhibiting the flashes of aggression and hostility that would overshadow his baseball career. In Salem, Massachusetts, in 1892, the *Sporting News* referenced an "imaginary grievance" of Bergen's for which he gave another player a "bad beating." In Lewiston, Maine, in 1894, he played brilliantly, but a teammate would later tell the *Worcester Evening Gazette* that "[he was] so cranky that hardly anyone could get along with him and it was only by the greatest diplomacy that he was gotten along with at all."

He moved on to the Kansas City (Missouri) Blues, where he thrilled fans with his skillful catching and superb hitting—in July 1895, he led the team with a .407 batting average. But he grew increasingly temperamental. In July 1893, he had married Hattie Gaines, a young woman from upstate New York who worked as a stitcher in the Batcheller shoe factory. He wanted her to join him in Kansas City, but she chose to stay with her family in New York instead. Living in a strange city apart from his wife upset him, and near the end of the '95 season, Martin walked out on the Blues and went home to North Brookfield to sulk.

He wasn't idle for long. His level of play had caught the attention of manager Frank Selee, whose Boston club was looking for a replacement for their star catcher, Charlie Bennett, who had lost both legs in a train accident in '94. Selee was willing to overlook Martin's reputation for moodiness and gave the Blues $1,000 and shortstop Frank Connaughton for the talented catcher. But Selee had to personally make the trek to North Brookfield to deal with Martin's salary complaints. Martin wanted $2,400, the maximum allowed under the National League's salary cap, but Selee persuaded him to be patient. It would take two seasons—much of '96 was lost to injury—before Martin earned top dollar.

In '97, Martin seemed to settle down a bit, dazzling fans and earning the respect of his teammates as the Beaneaters took home their fourth pennant in seven years. The powerhouse squad took his moodiness in stride, seeing him as a key player on a team that included four future Hall of Famers: William "Sliding Billy" Hamilton, Charles "Kid" Nichols and the "Heavenly Twins" Hugh Duffy and Tommy McCarthy.

Life at home was good, as well. Martin and Hattie's family had grown to include three children: Florence, born in 1894; William, born in 1895; and Joseph, born in 1897. In 1898, when the Beaneaters beat the Baltimore Orioles for their second consecutive National League pennant, Martin bought a sixty-acre farm on Boynton Road about two miles west of North Brookfield

center. He called it Snowball. For Christmas, the club sent a generous gift to the growing family: "Two handsome horses, a carriage, sleigh, harness and a piano," according to the *Springfield Union*.

But the brief spell of relative calm was about to turn sour. Martin turned in his best season in '98, hitting .289 in 120 games and gaining recognition as the best fielding catcher in the game, but his behavior grew increasingly erratic. The *Boston Morning Journal* reported that he had "assaulted several of the most inoffensive members of the team while in the west." After one altercation on the bench, he threatened to club his teammates to death.

Bergen, seen here in an Elmer Chickering cabinet card portrait, was considered the best fielding catcher in the National League. *National Baseball Hall of Fame & Museum.*

On the morning of July 28, things came to a head in the genteel dining room of the Southern Hotel in St. Louis, when twenty-two-year-old rookie pitcher Vic Willis took a seat at Martin's table with the intention of getting to know his catcher. Martin growled, "If you don't get away from me, I'll smash you, sure!" When Willis didn't flinch, Martin reached out and slapped his face. Willis was ready to fight, but other players urged him to leave the room, and Selee told him not to retaliate. The team was trying for its fifth pennant, and any animosity was buried until the season was over. Obligingly, the press also buried the story.

But in mid-October, after Boston had won the pennant, the *Sporting News* gave a detailed account of the incident, including a statement from an unidentified teammate: "It's his disposition to be gloomy and morose and we give him all the latitude we can in order to keep peace with him. That scrap

with Vic Willis was an outrage. Bergen made an ass of himself and brought discredit on us all by his inexcusable conduct."

The *Nebraska State Journal* predicted that "Martin Bergen, the eccentric catcher of the Boston team…[will likely] be traded before the opening of next season, as Selee says he has stood Bergen's crankiness as long as he can."

INTO THE DARK

In 1899, Martin suffered two shattering blows: Hattie was diagnosed with tuberculosis, almost certainly a death sentence in those days, and his son Willie died of diphtheria in April. His grief was compounded by guilt over the fact that he was on the road with the team when the boy died. He arrived late to the boy's funeral and later told a neighbor, "It's pretty tough that my boy should be taken away, but it seems a great deal harder still to think that I should just get home in time to see him being taken out of the door in a box."

The tragedy haunted him, mingling with imaginary terrors in his head. He became convinced that his teammates were taunting him and making jokes about the child's death behind his back. He complained bitterly that they were out to get him, even claiming that they were plotting to kill him. As his paranoia escalated, he adopted peculiar habits, such as walking sideways or sitting with his feet in the aisle in trains in case someone decided to attack him.

In July, at the beginning of a long western road trip, Martin hopped off the train when it stopped briefly in Washington, D.C., and returned home to North Brookfield. It was not his first unauthorized walkout, but it riled his teammates because, as they chased their third consecutive pennant, they were left with only a backup catcher for game after game in the summer heat.

He returned to Boston a little more than two weeks after he had left the team, only to go AWOL again in early September. A wire article described him as "the erratic catcher of the Boston club, who has deserted the club annually since his connection with it and always at a time when his services were most needed."

On October 9, he had a psychotic episode while catching against Philadelphia. He began dodging pitches, imagining that an assailant was taking fierce stabs at him with a knife. Selee had to pull him from the game.

The next day, a headline in the *Boston Globe* screamed, "Bergen Makes a Farce of His Position."

Martin's surly and unpredictable behavior created tension in the clubhouse, causing many teammates to shun him. The discord was widely viewed as the main reason for the Beaneaters' failure to win the pennant that year. The *Sandusky Star* wrote, "It is now conceded that the Boston nine dropped out as a champion factor largely because of the trouble between the players and Martin Bergen, the catcher. Ever since Bergen's first desertion of the nine there has been a feeling of bitterness."

The *Bangor Daily Whig and Courier* wrote, "Marty Bergen is accused of creating dissention in the Boston team, which is the cause of the champions' recent defeats."

At the end of the season, some players openly said that they would not return to Boston if Martin was still on the team. When Selee was asked about the future of his unreliable catcher, he responded, "He is insane. I've done everything in my power to get along with him. He is possessed of the insane idea that none of us like him. I will have to get rid of him. He is the greatest catcher in the business, but...there is no use trying to keep him on the team."

Martin returned home, the only place he said he felt happy. But even home could not calm what he described as a circus going on in his head. As Martin's grip on reality faltered, his brother, William, summoned the local physician, Louis Dionne, who was also a friend of Martin's. Dionne later told the *Boston Herald* that Martin complained that people were trying to injure him. A fan had given him a congratulatory cigar, but he was afraid to smoke it because "it looked to me like poison. I thought this man had been told to...kill me." When Dionne mixed a sedative for him, Martin refused to take it because he "thought someone in the National League had found out that you were my family physician and had arranged to give me some poison. I did not take it from my wife because I didn't wish hers to be the hand that poisoned me."

In November, Dionne returned to the farm to attend to Hattie, who was lying on the sofa and coughing up blood. Martin was distraught, crying, "The sight of that blood drives me crazy!" On January 14, 1900, Martin went to Dionne's office to get some medicine for Hattie. Dionne later reported that Martin seemed confused and had trouble remembering events of the previous year. As he left the office, he told the doctor, "This has been a very pleasant talk, and yet it's strange how it has rattled me. I'm almost crazy."

Four days later, on January 18, he rose early as usual, did some chores and cooked breakfast for his family. He had ordered a supply of groceries

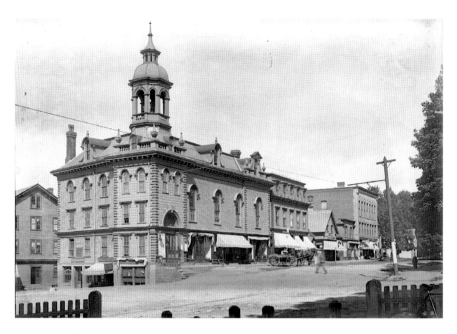

North Brookfield was the only place Bergen said he felt happy, but in the end, even that failed him. *LeBeau-Morrill Bullard Collection.*

from Boston and borrowed a neighbor's sleigh to go to town to fetch them. The neighbor, Mrs. Collins, watched him walk across the yard holding his children by the hand. "Hello, here comes farmer Bergen!" she called out.

Martin laughed. "What kind of farmer do you think I make, Mrs. Collins?"

"I think you will make a very good farmer, Mr. Bergen," she replied.

Martin shook his head. "I don't think I will ever make a good farmer."

He left his children with Mrs. Collins and set off for town with his father, Michael, who had recently come to live at Snowball farm. Michael's drinking had become a source of conflict between them, and his father was consigned to sleeping in the barn.

At E.W. Reed's Drugstore, Martin filled the prescription that Dr. Dionne had given him for Hattie. A customer in the store who had read about trade talks involving the town hero asked, "Are you going to be playing ball, Martin?"

"No, I'll never play another game of ball," Martin predicted. He left his father in town and drove back to Mrs. Collins's farm without his groceries, which hadn't arrived. He took his children by the hand and returned home to give Hattie her medicine, spend a quiet afternoon with his family and cook supper as the short winter day dwindled to night.

THIS INSANE DEED

No one can say what demons visited Martin as he lay on the couch through that long night. Sleep, if it came, was most likely fitful. Outside his windows, the snow-blanketed farm lay in deep silence. His wife and two small children dozed in the adjoining bedroom.

At around half past five o'clock in the morning, as was his custom, he rose and made his way through the darkness to the kitchen stove. The chickens and cows and horse needed tending, but his first task of the day was to light a fire. He lay some newspapers on the grate and went to the shed for kindling, as he had done hundreds of times before. But the fire was never lit. Somewhere between the intent and the act, the frayed circuitry inside his head snapped. He seized the axe and in a psychotic fury rushed into the bedroom to quell the demons in one final, frenzied confrontation.

Hattie, who had once assured Dr. Dionne that she did not fear her husband, stood by the bed. She raised her arms above her head in a futile gesture of self-preservation. But there was no protection from the axe her husband wielded with a batter's practiced skill. He rained blow after blow on her head, crushing her skull. She fell on the bed, her arms still raised as Florence and Joe ran screaming from the room.

Their father chased them, slicing the top from the little boy's head with a single savage blow and then picking up the lifeless body and flinging it back into the bedroom. Florence, stronger and quicker, crouched trembling behind a kitchen chair. Martin struck once with the axe and broke a piece off the chair. His second swing did not miss. He struck her again and again, this eldest child, this beloved daughter, as she lay limp on the floor in front of the stove. The life blood drained out of her body.

When all was still, when the little farmhouse was full of the smell of carnage, Martin took a straight razor from the kitchen shelf. A madman watched from the mirror above the sink as he cut his own throat with such force that his head was nearly decapitated. The razor dropped to the table as he collapsed beside his daughter.

His father found them later that morning. As word spread, hundreds of ghoulish onlookers came to peer through the windows as policemen, doctors, the coroner and the undertaker performed their somber tasks.

The next day, the bodies were laid out for viewing in the house and then taken to the church. Only two baseball men attended the funeral service: legendary Major League Baseball manager Connie Mack, who hailed from neighboring East Brookfield, and Billy Hamilton, Martin's roommate on the

The Bergens were parishioners of St. Joseph's Church, where their funeral service attracted more than one thousand mourners. *LeBeau-Morrill Bullard Collection.*

road. Selee sent flowers. So did newspaper writer T.H. Murnane, who sent twenty-eight white flowers with a background of ferns along with a note: "May these flowers speak a word of charity for Martin Bergen, who has done this insane deed." The twenty-eight flowers lay on top of twenty-eight-year-old Martin Bergen's casket as the funeral procession wound slowly up the hill to St. Joseph's cemetery.

A single broad grave received the bodies. It remained unmarked until 1934, when Connie Mack raised funds to erect a granite memorial in recognition of Bergen's contributions to America's national game. The inscription reads, "In memory of Martin Bergen 1871–1900." It makes no mention of the wife and children who lie beside him.

CHAPTER 8

SLAUGHTER OF INNOCENTS

In 1901, distraught mother Elizabeth Naramore brutally killed her six small children in the peaceful village of Coldbrook Springs.

Thursday, March 21, 1901—the first day of spring after a long, hard Massachusetts winter. The frozen landscape had begun to thaw. The endless snow was giving way to raw patches of dark earth and tender green. Birdsong trilled from still-bare trees, bringing promise of warmer days to come, singing songs of hope.

At home with her six small children in the tiny village of Coldbrook Springs, Elizabeth Naramore heard neither the promise nor the hope. The house in which she lived was a cold, ramshackle heap of a place with drafty walls, bare wood floors and broken windowpanes through which the cruel winds howled. The furnishings were meager: "a rickety table, nine kitchen chairs, a stove, not fit for a lumber camp, three beds, not worth a cent a piece, tied up with strings." No pictures adorned the blank walls. No curtains hung at the narrow windows. No flower, photograph or ornament relieved the stark poverty of the grim interior.

The children were pinched and pale with hunger. Their father, Frank, had taken two biscuits with him when he left for work at the sawmill that morning. The children had eaten the rest, careful not to waste a crumb. Now the cupboards were bare. Only baby Lena was nourished, suckling greedily at her mother's breast.

But mother's milk does not spring from love alone. In desperation, Elizabeth had swallowed her pride and sought help from the overseers of the poor. Last Friday, they had responded with a home visit that revealed the harsh reality: the children were malnourished, the house unfit for human habitation and the father unable or unwilling to provide. Well meaning and in accordance with the law, they proposed a remedy. She must leave her husband, allow the children to be placed with foster families and go with her baby to the poorhouse. They promised to return the following Friday to remove the children.

For six days and six nights she anguished, terrified by the thought of never seeing her children again, horrified by the notion of delivering those defenseless lambs into the arms of strangers. She paced the floor, wracking her brain, praying for a miracle. Begging Frank to do something—*anything*—to save them.

On Wednesday, she had run up to a passerby, a complete stranger, crying, "What would *you* do if someone was going to take your children away from you?" That night, in the still hour between eleven and twelve o'clock, a sickly neighbor a quarter mile away heard her screams. No help came.

Thursday dawned blank and hopeless. Yet a certain settled calm had descended on her. She was unusually cheerful when she bade Frank farewell. She watched the children finish their meager meal at the kitchen table and nursed the baby cradled in her arms. Then she lay the infant on a bed. She locked and barricaded the doors with planks of wood. Her movements were decisive and assured. Methodical, as if she were carrying out a carefully plotted plan.

Did the children watch as she moved about the room? Did they turn their innocent gaze to her in wonder or surprise? Did they sense something different about her, an indefinable strangeness, as if this woman, this mother, were not their own? Or did they chatter happily away with childlike unconcern as she took the axe from where it stood in the corner near the stove? Did the first fatal swing of the weapon take them completely by surprise?

We'll never know, just as we'll never fully comprehend the utter horror that befell them. What we do know is that she first struck her eldest child, Ethel Marion, nine years old. When the little girl was limp and lifeless, she carried the bloodied body into the bedroom and lay her on a bed.

She returned to the kitchen, to the terrified children, where little Charles Edward, age seven, was next. And so it went in descending order of age: Walter Craig, six; Chester Irving, four; Elizabeth, three—all bludgeoned with the axe, all laid carefully on the beds, three on one, two on another.

Their blood pooled on the floor and kitchen table and rickety chairs. It splattered across the bare walls and grimy windows. It soaked through the ragged bedding and dripped onto the floorboards like the relentless patter of ghastly tears.

Only one child remained, Lena Blanche, just six months old, unable to run away or cower beneath the table or raise her tiny arms in a futile gesture of self-defense. Her mother dropped the axe and took up a heavy club. With one swift blow to the head, the infant was silenced forever.

When the frenzy had passed, when the mist of blood and madness lifted, she surveyed the slaughter. All dead. All gone to a better place. She took a razor and slit her own throat. To make doubly sure, she slit her wrists and an artery in her leg. Then she gathered baby Lena in her arms, lay down beside her dead children and waited to die.

FOR BETTER OR WORSE

Elizabeth Ann Craig was born to Josiah and Hannah (Clark) Craig in St. Andrews, New Brunswick, in about 1865. Left motherless at the age of sixteen months, she and an older sister, Hannah, were raised by their father. The family was poor, and both girls began earning a living as domestics at an early age. Elizabeth worked at a hotel for about two years, where the owner remembered her as a "good, willing, industrious, and virtuous girl."

She eventually immigrated to the United States, where she found work as a housekeeper for the family of Herbert Small Morley, of the H.M. Small Paper Manufacturing Company of Baldwinville, a village in Templeton, Massachusetts, about forty miles northwest of Worcester. She stayed with the family for several years before renting part of a house and striking out on her own as a dressmaker. To enhance her modest income, she also took in boarders.

Elizabeth flourished during those years in Baldwinville, where she attended the Baptist church and acquired a reputation as an honest young woman with good moral character. She was trustworthy, resourceful and ambitious, someone who was trying to get ahead in the world and willing to work hard to get there.

She wrote frequently to her father, often sending money and small gifts. She urged him to join her and offered to help him find employment, but he preferred to stay in New Brunswick. She continued to write after her

marriage, but the letters no longer contained gifts. In time, the letters became fewer and fewer and eventually ceased altogether.

After the tragedy, the Morley family described her as "as good a girl as anyone could wish…pleasant about the house and kind to the children…economical and thrifty in every way…well-fitted by disposition and traits of character to have made a most estimable wife and mother."

The only hint of what was to come—the only glimpse of a potential fault line Elizabeth's temperament—was the Morleys' comment that "[w]hile she was of a nervous disposition, easily startled, she never showed it in anger or moroseness." That "nervous disposition" would be tested to the breaking point after her marriage to Frank Lucius Naramore on October 25, 1890. She was twenty-five. He was twenty-six and had already acquired a reputation for shiftlessness.

Frank was born in Winchester, New Hampshire, to Lucius and Minerva (Warren) Naramore. He was over six feet tall, broad-shouldered and muscular. He worked in sawmills and lumber camps—his brothers owned a sawmill in Winchester—when he chose to work. It's not known what brought him to Baldwinville, but while there he spent much of his time and money in barrooms, where he was "one of the boys." Some acquaintances described him as "a pleasant enough fellow," but he had a temper and became quarrelsome when he'd had too much to drink. More than once he was arrested and fined for fighting. The Morleys later said, "We were very, very sorry when we heard that she [Elizabeth] was married to him, as we did not think from what we could learn of him that he was nearly good enough for her."

Whatever attracted her to him, and whatever dreams she may have harbored when she became his bride, Elizabeth's married life quickly descended into one of unremitting hardship. Soon after the marriage, the couple moved about eighteen miles down the road to Barre Plains, a section of the farm town of Barre. There, she was isolated from the support and potential influence of her Baldwinville friends who might have persuaded her to leave him.

Elizabeth did her best to make a comfortable home for her rapidly growing family. She bore six children in nine years—the fourth born dead—and used her housekeeping skills and frugality to make the most of Frank's sporadic income. She paid for repairs to their rented rooms to create a "sitting room," where an organ she had brought from Baldwinville held pride of place. Nurses who attended to her during childbirth reported that the home was always tidy and the children clean and well cared for.

But Frank's drinking, temper and aversion to work took an increasing toll on his family. He was a drinking man when she met him, but like many women, she may have believed that she could change him. She quickly learned otherwise. She learned, too, to fear the disagreeable effects of his drinking. Employers and fellow workmen recalled that when he was drinking he was generally quarrelsome and ugly. He was especially abusive to Elizabeth. She sought advice from clergy and others in positions of authority, confessing the trouble that his drinking was causing her and the children. After one particularly abusive episode, a warrant was issued for his arrest, but she relented and the matter was dropped.

One fellow workman recalled that in addition to his sour disposition, Frank was physically unclean. "Having worked with him, boarded and lived with him, I found him a beastly man," he reported. "He had to be made to wash himself before meals when boarding with the men."

He was also extravagantly wasteful of money. Despite the needs of his growing family, stories of his improvidence were legion. He once spent two dollars on a pipe, holding it up for all to admire and exclaiming, "Isn't that a beauty!" He paid four dollars for a pair of miner's rubber boots, which were utterly useless in a sawmill. He bought shares in a goldmine that turned out to be worthless. A man invited to drink with him recalled that after Frank had paid for the two drinks, he "regretted to observe that he had only three cents left." Once, he drew two weeks' pay in advance and went to Worcester to buy furniture. He returned home three days later with neither the furniture nor the money.

As an employee, he was regarded as strong, able and possessed of good mechanical ability. He could turn his hand to almost any kind of repair and do good work. But his disposition made him extremely difficult to manage. Once, when he was asked to cut some wood, he smashed the saw instead. A former employer recalled:

> *You have to drive him, coax him, and know how to handle him to get any value out of him. He was always in trouble with the help and there were so many breaks to mend between them that I would not have kept him nearly as long as I did, only for his family. He got to bringing liquor onto the lot for the men, which of course caused trouble, and so I turned him off, wishing for him the best success I could.*

If Elizabeth hoped that time and experience might improve Frank's nature, she was to be sadly disappointed. Years passed and life slipped ever downward

for the Naramores. Frank worked only when he felt like it. His drinking grew steadily worse. When the older children went to school, they spoke of their father's drinking and his ill treatment of their mother. Elizabeth's housekeeping began to slip. She was not quite as meticulous as she had once been.

Then, in 1900, the family left Barre Plains and moved into a dilapidated old farmhouse in Coldbrook Springs. Elizabeth may have dreamed of a fresh start. In reality, it was the beginning of the end.

ON TO COLDBROOK

Coldbrook Springs in 1900 was a small village just over the Barre town line in the northwest corner of Oakham, a farming community with a total population of about 750. The village had only around thirty houses, but it attracted a large number of visitors, who came to enjoy the healing qualities

The Baptist church where the children's funeral service was held stood near one of Coldbrook Springs' two train depots. *LeBeau-Morrill Bullard Collection.*

of its sulfur and iron springs. There were also two hotels—each with a saloon—a post office, a machine shop, a box mill and two train depots, one each for the Massachusetts Central Railroad and the Ware River Railroad, which both stopped at the village.

The house that the Naramore family moved into had stood empty for many years. A once stately home built in the early 1800s, it had been owned by the Whiting and Babcock families, who had been unable to keep the farm prosperous. During the Babcocks' occupancy, an itinerant tinker had hanged himself in one of the upstairs rooms. They sold the property to a lumberman, who felled all the trees and rented the tumble-down house to the family of seven.

Elizabeth was pregnant when they moved in. At first, she seemed to regain some of her old energy and set about improving her new home. She cleaned the interior of the house, finding a special place for the organ, that symbol of respectability that had come with her all the way from Baldwinville. She raised chickens and sold what eggs and chickens she could. She kept a small Jersey cow and planted a garden. She cut wood for the stove and carried water from the well.

Frank found work at the Parker lumberyard about two miles away. But work didn't agree with him. He forced her to sell the organ and then quit his job since the family was now in possession of twenty-five dollars. It was haying season, and men were in demand. But he refused to work. A neighbor wanted to hire Frank to help chip wood, but again he refused.

When the money was gone, he forced her to sell the cow, which she had struggled to keep for the sake of the children. A farmer had offered him free hay for the animal and a team for his use if he was willing to cut the hay. But he turned down the offer, preferring the easy cash instead.

Fall came and with it the birth of Elizabeth's seventh child, Lena. There was nothing left to sell. The garden had yielded pitifully little. The chickens were eaten or sold. Winter lurked just around the corner. When it came, it brought brutal cold and biting winds. Temperatures hovered around zero. A concerned citizen offered the family free window glass and putty to repair the broken panes. Frank rejected the offer, so Elizabeth stuffed the broken panes—seventy-six of them—with rags. Their supply of firewood dwindled, and the ineffective stove went cold.

Somehow, they endured. Kindly neighbors gave them food and wood. Frank brought in a little money now and then, some of which he spent on groceries but most of which he spent on drink. Elizabeth managed as best she could, eking out meager meals to keep the children one step ahead of

starvation, using just enough of the precious wood so they didn't freeze to death.

Somewhere in those dark, bitter months of winter, when the nights closed in early and the days dawned blank and gray, hope began to die. She was thirty-six years old and worn down by relentless poverty, worn out by unremitting hardship. She stared the facts in the face: Frank was not going to save them. Life was not going to get better unless she did something. And so, as the days lengthened and the air softened with the promise of spring, she asked the authorities for help. They told her that they would take her children away.

That was the final blow. She who had endured so much could not endure this final agony: the loss of her children. With nowhere to turn—her sister long dead, her father aged and she herself perhaps afflicted with postpartum depression—she made her desperate plan. She and her little lambs, her precious babies, would depart this woeful world together.

Except that Elizabeth did not die.

The Sins of the Father

On the day of the murders, Frank had decided to go to work. On his way, he stopped at the grocer's, C.H. Parker & Son, to have some potatoes and flour delivered to the house that day. An employee, George Thrasher, arrived at the house at about 2:45 p.m. He saw no one about and was unable to open the door. Curious, he peered through a window and saw blood on the floor. Elizabeth was lying on a bed.

Suspecting that something was wrong, he returned to the store to report what he had seen. Someone was sent to the sawmill to summon Frank, while a group of villagers rushed to the house and forced their way inside. What they found was horrifying. The kitchen was awash with blood. A bloody axe and club lay against the cold wood stove. In an adjoining bedroom, the bodies of the two oldest children lay on one bed. The bodies of the other three lay on another. Elizabeth lay across them, the baby clutched in her arms. When Frank arrived on the scene, he became hysterical and was taken outside to await the arrival of the medical examiner, Dr. Henry J. Walcott Jr. of Barre.

Elizabeth, though severely wounded, regained consciousness. She confessed to Deputy Sheriff Sylvester Bothwell of Barre that she had

The Naramore children were interred in Riverside Cemetery, which lies almost forgotten along a little-used dirt road. *Author's collection.*

murdered her children. An undertaker came to the house to prepare the bodies for burial, while their mother was taken to the Bemis Hotel in Coldbrook Springs and then to a Worcester hospital. She was arraigned in Worcester the following Monday before Judge Matthew Walker.

Because Coldbrook's Baptist church did not have a regular minister at the time, Reverend Charles H. Talmage of the Barre Congregational Church came to the church to conduct the children's funeral service on Saturday, March 23. Six little coffins were lined up at the altar. The coffin lids had window glass, which enabled viewers to see the damaged faces. Frank sat in the front pew of the church with his brother and brother-in-law.

The Coldbrook Springs cemetery was within walking distance of the Naramore home, but it did not have a paupers' section and no one had come forward to pay for a burial in the Baptist cemetery. So the children were taken to a single pauper's grave at the Riverside Cemetery in Barre. No stone marked their burial site.

Talmage, who had never heard of the Naramores before the murders, was deeply moved by the tragedy. During his funeral oration, he criticized society

for allowing conditions to exist that could result in such horror. Then he embarked on a personal crusade to understand what had led to the tragedy.

He investigated Elizabeth's and Frank's backgrounds and contacted many people who had known them—not, as he said, "with a sensational interest… but, as the friends of these dear old New England towns, we are stirred to the uttermost, with moral, psychic questions, of greatest moment, if we would meet the rapidly increasing problems, not only of city, but country social life."

He presented his findings—the "essential and representative facts" of the Coldbrook murders—to a packed audience at Williams Hall in Barre Center on Sunday, April 14. There, he pointed the finger of responsibility squarely at Frank Naramore. The father, he said, had driven the mother to madness through his indolence, neglect and abuse. But Talmage did more than assign blame. He urged his listeners to find solutions so that such a tragedy might never happen again. His address was printed in full in the *Barre Gazette* on April 19, 1901. Talmage helped shape public opinion toward Elizabeth, causing many to view her with compassion and pity.

Certainly, the courts saw her actions as those of an unfortunate woman driven to madness by almost unendurable hardship. She was tried for the murder of her eldest child, Ethel Marion, and found not guilty by reason of insanity. Sentenced to life in the Worcester Lunatic Asylum, she was released five years later on December 3, 1906, after being declared completely cured by hospital superintendent Dr. Hosea M. Quinby and pardoned by Lieutenant Governor Eben Draper.

Five years after being sent to the Worcester Lunatic Asylum, Elizabeth Naramore was declared completely cured and released. *LeBeau-Morrill Bullard Collection.*

On September 8, 1907, Elizabeth visited the unmarked grave of her murdered children. She was working in a Boston department store by then, and she reportedly vowed to return in the spring and have a memorial marker erected. She was never heard from again, and her fate is unknown.

Frank eventually moved to Worcester, found work as a carpenter and boarded with a family on Congress Street. He died in Worcester in 1936, but no grave site has been found.

As for the Naramore children, they lay in silent anonymity for more than one hundred years. Only a giant oak looked over them, and a slight indentation in the ground marked their final resting place.

In the 1920s, the village of Coldbrook Springs itself disappeared, taken by the Metropolitan District Commission as part of Quabbin Reservoir aqueduct system. Much of the land reverted to forest, intersected by stone walls and dirt roads, dotted here and there with a few cellar holes where a village once stood.

The Riverside Cemetery lies along an old dirt road. It is a quiet place, tucked among the spreading trees with only the song of birds to break the brooding silence. On August 4, 2002, about three dozen people gathered at the cemetery to right an old wrong. They included members of the Barre Historical Society, local politicians and the Massachusetts secretary of state. Their purpose was to remember the six slain children and to erect a granite memorial marker. The marker is inscribed with their names and ages:

Ethel Marion Naramore age 9
Charles Edward Naramore age 7
Walter Craig Naramore age 6
Chester Irving Naramore age 4
Elizabeth Naramore age 3
Lena Blanche Naramore age 6 months.

The back of the stone carries this inscription:

Elizabeth Ann Craig and Frank Naramore lived in nearby Coldbrook, where they raised six children. Desperately poor and fearing the separation of her family, Elizabeth murdered her children on March 21, 1901. She attempted to take her own life, but did not succeed. Today, many of the laws in the Commonwealth regarding child protection find their origin in the Naramore Case.

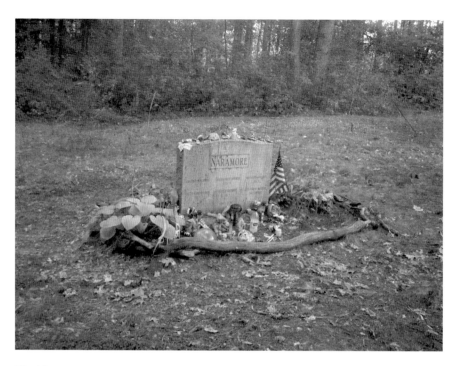

The Naramore children's pauper's grave was untended and unmarked for more than one hundred years. *Author's collection.*

People sometimes visit the grave. Some leave small gifts for the children—dolls, toy cars, stuffed animals or rubber balls. Occasionally, some may pause and hear a vague, faint echo of the words with which Reverend Talmage concluded his stirring address so long ago:

> *What modifications of law, what new laws, shall the old Commonwealth of Massachusetts make for such desperate cases? What preventions and what remedies? What warnings and what punishment? What new atmosphere shall we create and how, for social regeneration and righteousness? What functions for church and state? What co-operations and sympathies to deliver and save such mothers and children?*

His words still challenge us today. His questions still remain unanswered.

"AMERICAN TRAGEDY" ON LAKE SINGLETARY

On August 4, 1936, choir singer Newell Sherman went to the electric chair for the drowning death of his wife on Lake Singletary in Sutton—a crime the media likened to the novel An American Tragedy.

On the warm Saturday night of July 20, 1935, twenty-six-year-old Newell Paige Sherman went to choir practice as he did most Saturday nights. He had a wonderful voice and loved singing at Sutton's First Congregational Church, which he had attended since childhood.

He may have felt an extra twinge of excitement that night, for he had planned a special outing with his wife, twenty-two-year-old Alice (Dudley) Sherman. She was at home—times were tough and they lived with his parents—with their two young children, two-year-old Janice Mae and four-month-old Dudley Paul. When choir practice ended, he had promised to take her for an evening canoe ride on nearby Lake Singletary.

It was a romantic gesture, and Alice dressed for the occasion. She wore a sleeveless white cotton pique dress with a square neck bound with red, a red button at either corner and a red-and-white belt at the waist. She tied a ribbon in her long brown hair and tucked a lace-edged handkerchief into her pocket. On her feet she wore the new flat slippers that Newell had bought her at Empire Shoes in Worcester earlier that day.

At five feet six inches tall and weighing only 118 pounds, Alice was an attractive woman with a slim figure, brown eyes and a clear complexion. Her husband, who stood six-foot-four and weighed 240 pounds, had a

This press photo shows Newell Sherman in Worcester "after he had been grilled by police in connection with the 'American Tragedy' drowning of his wife, Alice." *Author's collection.*

burly build that contrasted pleasingly with his boyish face and mop of curly hair.

After two and a half years of marriage, Alice was still in love with her husband. True, having two children so close together had put a strain on their relationship. She'd had to take the children to her parents' house for five days because little Janice Mae refused to sleep alone. The child's crying got on Newell's nerves. And there'd been that fuss about Esther Magill, the brazen teenager who worked with Newell at Whitin Machine Works. Newell had even consulted a lawyer in Uxbridge about getting a divorce. But the lawyer had advised him against it, and he'd come to his senses. He'd chosen to stay with his wife and family.

He arrived home at about 8:45 p.m., wearing the overalls and chambray shirt he'd changed into that afternoon. She finished putting the kids to bed, and they set off for the Nookto boathouse—about a ten-minute drive away—where he had reserved a canoe for fifty cents earlier that evening. She had never been in a canoe before, but she had confidence in Newell's abilities. He'd grown up around the lake and was a strong swimmer, should anything go wrong. Not that she expected it to. If anything, she was relaxed and happy to be out with her husband. It would do them both good to spend time alone together, to rekindle the romance that had led them to marry less than eight months after they met.

Newell helped her into the canoe and pushed it off the shore before climbing in behind her. Taking up the paddle, he headed south across the length of the lake toward his father's land near Benjamin's wall on the opposite shore. It was a warm night, calm and overcast with no moon. Dusk was dwindling into darkness. There were murmurs of voices from swimmers and other boaters, and here and there along the shoreline shone warm pools of light from summer cottages.

His father's stretch of land was dark and private. According to a story Newell would repeat many times, he beached the canoe and then made love to his wife—"a little love party," as he put it. After about forty-five minutes, they set off again. It was about 10:30 p.m., and a misty fog was drifting in. He paddled on, the water dully gleaming, the air dense and heavy, the silence broken only by the steady slice of the paddle.

He would give several versions of what happened next, but somehow the canoe overturned and they fell into the water. Alice, who could not swim, screamed for help, flailing frantically, her pretty dress weighing her down. She grabbed for her husband, who was big and strong and a powerful swimmer. When she clutched at his shirt, he twisted away to remove his shoes, which were a hindrance.

The canoe did not sink and was only a few feet away. But Alice, for all her desperate thrashing, could not reach it. Gasping, floundering, she struggled futilely for a moment. Then she vanished beneath the surface. Her husband swam back to the canoe and tucked one end of it securely under his arm. He treaded water for a while, holding onto the boat, watching bubbles rise where his wife had gone under. He watched until the bubbles ceased and the roiled water turned glassy smooth again.

Then, hugging the canoe against his body, he swam to shore, less than one hundred feet away, and ran for help.

A Twisted Tale

Newell Sherman was well known in Sutton, a farm town of about 2,500 people eleven or so miles south of Worcester. He was the youngest of four children—two boys and two girls—born to Louis and Emma Sherman. The family had lived in town for generations, which counted for a lot in New England. His father was a farmer and blacksmith who had served as town constable for thirty years, as had his father before him. Newell was a Boy Scout leader and a talented musician who not only sang with the church choir but also played violin in the local orchestra.

He was also a hard worker. On the morning of the drowning, he had cultivated two acres of field grass with his nephew and helped another nephew take apart a Buick for disposal. Then he had driven into Worcester with his wife and nephew to try to sell—unsuccessfully—three tires at Standard Wrecking and Lindy's Junk Yard. Last summer, he had helped build a new dock at Marion's Camp, a well-known girls' summer camp on Lake Singletary.

It was to the caretaker's cottage at Marion's Camp that he first ran to summon help, and soon a small search party set out in two boats. But the fog had thickened, and the men could find no trace of Alice on the 330-acre pond.

At first dawn, the police organized a search team of ten or twelve boats manned mostly by volunteers. Newell and his brother-in-law, Norman Perry, were among the searchers, but it was a twenty-two-year-old electrician named Dwight King who located the body of Alice Sherman about thirty feet below the surface. He used grappling hooks to pull her from the water at about ten o'clock in the morning. She was taken to Marion's Camp to await the medical examiner.

Newell often worked with his father in the blacksmith shop that the Sherman family had owned for generations. *Author's collection.*

Meanwhile, despite his family's prominence and his own standing in the community, Newell Sherman was already being viewed with suspicion. Detectives called to the scene heard rumors of his involvement with a young woman named Esther Magill. He had gone home after Alice's body was retrieved, but Detective Edward J. McCarthy, a twenty-two-year veteran of the Massachusetts State Police Force, wanted to talk to him. He ordered Patrolman Albert J. Sheehan to go to the Sherman house and ask Newell to accompany him to the State Police Barracks in nearby Grafton.

By the time McCarthy arrived at the barracks, Newell was already waiting for him. McCarthy, Sheehan and Corporal Robert E. Thompson took him to an upstairs room and proceeded to question him about the circumstances of Alice's death. Before the day was over, Newell Sherman had signed four typed copies of a confession in which he purportedly stated:

> *I deliberately tipped the canoe over, with the intentions of drowning my wife. After the canoe was tipped over I then thought of saving my wife and lost my nerve and thought only of saving myself. I turned*

deliberately around in the water to get away from the hold that my wife had on the shoulder of my shirt. She sank immediately after I pushed her away. I remained there and saw the bubbles and this was the last I saw of my wife's body.

The confession included a statement that would draw national attention to the case: "The reason for my act was my infatuation for Esther Magill of North Main Street, Whitinsville." On Monday, July 22—the same day Newell was arraigned on murder charges in Worcester District Court—the complete text of his confession appeared in the *Worcester Evening Gazette*. The morning edition of the paper, the *Worcester Telegram*, carried the full confession on July 23.

The national press soon picked up the story, drawing comparisons between the drowning at Lake Singletary and Theodore Dreiser's 1925 novel *An American Tragedy*. The novel was inspired by the true story of Grace Brown, who in 1906 was intentionally drowned by her lover in Big Moose Lake in upstate New York. The novel won many awards and spawned at least two movies in which an unfaithful husband plots to do away with his wife by drowning her.

Newell was quickly labeled the "American Tragedy Killer," although he always denied that he was inspired by the book. He also denied having made the confession, claiming that his interrogators had twisted his words and fabricated the whole thing.

The nation, in the depths of the Great Depression and perhaps eager for diversions, was riveted by the case with its parallels to a well-known story, its handsome choir-singing defendant and, most of all, its notorious "other woman," Esther Magill.

BABYLONIAN WOMAN

Newell had been trained as a machinist at Worcester Boys' Trade School, but the Depression kept him unemployed for three years. During that time, he worked in his father's blacksmith shop and on the family farm in Sutton. In August 1933, he secured a job at Whitin Machine Works, earning $23.60 per week. The job came as a welcome relief. He and Alice Dudley of Douglas, Massachusetts, had married on January 7 of that year, and she was expecting their first child in October.

Located in neighboring Whitinsville, a company town, Whitin Machine Works was one of the largest textile machinery companies in the world. Newell ran a lathe in the ring department. It was there, four months after his employment, that he met Esther Magill. She was sixteen years old when she joined the company on December 26, 1933.

Esther was a local girl who lived with her mother and father and older brother and sister. She usually walked to work—a distance of about a mile—and took the

Esther Magill, seen here with her brother, Andrew, was identified by the press as the "factory girl" who caused an "American Tragedy." *Author's collection.*

trolley home for lunch and at the end of the day. She was friendly and liked to kid around with her workmates. At first, her relationship with Newell was no different from any other—he was someone to talk to and laugh with to make the workday go by faster. Then, after a year, things began to change.

Newell started giving her rides to and from work in his old Packard. At Christmastime, he gave her a gift of ten dollars to buy a dress. After thinking it over, she returned the money to him. In January 1935, he invited her to go out with him. She refused, but the friendly banter at work continued. A few weeks later, he asked again. This time she accepted. She was seventeen when they started dating and Newell twenty-five, the married father of a little girl, his wife about seven months pregnant with their second child.

It wasn't easy for him to get out of the house, but he had orchestra rehearsals every Monday night, which provided an opportunity. One Monday in late January, after the rehearsal ended, he picked Esther up at her house and they went out for drinks—highballs made of whiskey and ginger ale—and something to eat at Caesar's Rendezvous on Chandler Street in Worcester. On the drive home, he parked on a side road, and they got into the back seat to hug and kiss.

On their third date in late February, after drinks and dinner at a small place in Woonsocket, Rhode Island, they parked along the Quaker Highway. This time, their lovemaking progressed further. On the witness stand, "by advice of counsel," Esther refused to answer the question of whether they had had sexual intercourse because "it might tend to incriminate me." Nevertheless, the implication was clear. They had consummated their relationship.

It was around this time that Alice gave birth to a baby boy—a fact that prosecutors would pounce on when Newell took the witness stand:

> Q. What day was your baby boy born?
> A. [Pause] Well, like a lot of fathers...
> Q. March 3, 1935.
> A. Yes, sir.
> Q. March 3, 1935.
> A. Yes, sir.
> Q. So that within two days of the date that your wife was to be confined to deliver you a son, you drove to Woonsocket and parked on a side road and were having intercourse with Esther Magill?
> A. No, Mr. Hoban! I was not!

Over the next month or so, Esther joined Newell at local social events, including a bean supper sponsored by the Boy Scouts, a supper at the First

Congregational Church and a Grange supper at the Sutton Town Hall. To lend an air of propriety, a friend always accompanied them. At one gathering that they attended separately, Newell introduced her to his wife.

On April 26, Newell's birthday, he hurried home from work and ate a slice of the birthday cake Alice had made and decorated with candles and little candies. Then he rushed off to the Odd Fellows Hall in Worcester, where he was to perform with the Sutton Grange orchestra. He took Esther with him.

Before the event ended, he and Esther snuck out to a place called the Pirate's Den for highballs. Newell spotted an acquaintance from Sutton, so they went downstairs to the Brass Rail. Newell said that "he loved me more than anyone else in the world," Esther testified. He asked if she would marry him if he got a divorce. She claimed that she told him no.

On May 15, Newell performed at a music festival at the Sutton Town Hall. Alice stayed home with the children—their house was a short walk from the town hall while he hired a taxi to bring Esther from Whitinsville to the event. His sister alerted Alice that it would be in her best interest to come to the festival. After arranging for someone to stay with the children, she arrived with Newell's mother about halfway through the performance.

When the music ended, there occurred what prosecutors would characterize as "the strangest journey that has ever been traveled by a human being in this life." With his wife beside him on the front seat and Esther on the back seat with his mother, Newell drove the seven or eight miles to Whitinsville to take Esther home. Long minutes passed in silence. At some point, his mother asked him to stop the car. On the witness stand, in a voice barely above a whisper, Esther described what happened next:

> Q. What was said there in that halt in your journey?
> A. Mr. Sherman's mother asked me if I had not gone far enough with the affair.
> Q. What did you reply?
> A. I asked her what business it was of hers.
> Q. What did she reply?
> A. She did not want to see a happy home wrecked.
> Q. What did you say?
> A. As far as I knew the home was not happy.
> Q. Was anything said after that?
> A. Sherman's wife talked.
> Q. What did she say?
> A. She said if I thought I was going to get her husband away from her I was out of luck.

Q. What did you say?
A. I told her time will tell.

The district attorney would make much of this exchange in his closing argument, characterizing Esther as a "Babylonian woman" with a "saucy mouth." Newell, he said, had at that moment been given a choice between virtue—represented by his wholesome wife and heroic mother—and vice, embodied by the brazen charms of Esther Magill. By saying nothing in defense of his wife and mother, and by failing to reject his "Babylonian woman," he had chosen vice. "From that hour on, Alice Sherman was a doomed woman," the prosecutor declared.

The confrontation had a cooling effect on Esther. She stopped going out publicly with Newell, but they continued to talk intimately at work. He began giving her money to save in a bank account for him. He was asked about that on the witness stand:

Q. Well, you gave her some money, too, in that time, didn't you?
A. Yes.
Q. To save for you?
A. Yes.
Q. So that she was sort of a banker for you?
A. Yes.
Q. You could have banked it yourself if you had wanted to, couldn't you?
A. I suppose I could.
Q. Why didn't you give it to Mrs. Sherman to keep for you?
A. I don't know.

Esther testified that his plan was to go out west and "get away from his wife and family." He wanted her to join him, she said, adding, "I didn't say I would and I didn't say I wouldn't."

Sometime in July, in one of their conversations at work, he confided that he was going to take Alice for a canoe ride. Esther claimed to have joked, "I hoped if the canoe tipped over he would go down three times and come up twice…[He said] he wouldn't, but someone else might."

Although Newell would say on the witness stand that the affair had ended in April and that he was fully committed to his wife, bank records showed that Esther deposited fifteen dollars—which Newell admitted he had given her—on July 19, one day before Alice Sherman drowned.

A Speedy Trial

The case of *Commonwealth v. Newell P. Sherman* was heard in Worcester Superior Court beginning Monday, September 23, 1935—two months after Alice's death—with Judge Thomas J. Hammond presiding. District Attorney Owen A. Hoban and Assistant District Attorneys Alfred B. Cenedella, Andrew A. Gelinas and Charles A. Barton represented the commonwealth. J. Fred Humes and William W. Buckley represented the defendant.

Newell pleaded not guilty to the charge of murdering his wife. His lawyers tried to suppress his signed confession on the grounds that police had violated his Fifth Amendment rights, but the judge allowed it to be admitted as evidence.

On Monday morning, a jury of twelve men was selected from a pool of forty-four potential jurors. (Massachusetts didn't allow women to serve as jurors until 1950.) Jurors were given time to notify their families and employers and to request any personal items they might need, as they would be sequestered until they delivered a verdict. In the afternoon, they were taken by bus to view Lake Singletary, the Sherman home and other sites relative to the death of Alice Sherman.

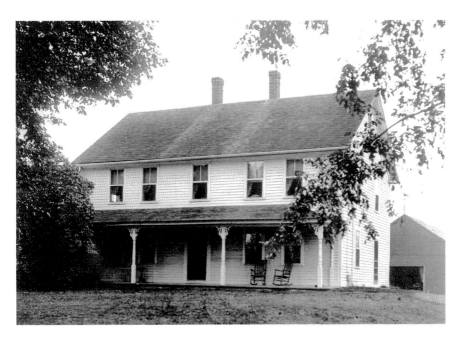

The press ran this photo of "the pretty country home in Sutton, Mass., of Mr. and Mrs. Newell Sherman." *Author's collection.*

Over the next five days, including Saturday, September 28, jurors heard testimony from a procession of witnesses, including Newell himself. Both sets of parents—William and Clara Dudley and Louis and Emma Sherman—were present for the duration of the trial.

The defense built its case around three arguments: 1) Newell Sherman was a loving husband and father and an upstanding citizen who had simply made a mistake with Esther Magill; 2) his wife's death had been a tragic accident; 3) the police had coerced him into signing a false confession. The prosecution's argument was as follows: 1) Newell Sherman was a cheating, lying, coldhearted murderer; 2) he had intentionally drowned his wife to be free to marry his mistress; 3) his signed confession was true and had been voluntarily given.

All three officers who had obtained the confession from Newell were called by the prosecution. All three told essentially the same story: that Newell had come willingly to the barracks on the day his wife's body was recovered, that he had freely confessed to intentionally drowning his wife and that his stated reason for his act had been his infatuation with Esther Magill.

Buckley tried, with little success, to show that the officers had coerced a confession by unlawfully holding and intimidating his client. He also argued, in his cross-examination of Officer Sheehan, that the investigators had fabricated most of the confession:

> *Q. That first paragraph is your composition, isn't it?*
> *A. On the first part of it I started out and put the words in to Patrolman Mitchell. It was on the machine, and it was for the approval or disapproval of Lieutenant McCarthy.*
> *Q. Well, was it written out by you, did you dictate it there, a written statement that you had already reduced to writing on paper?*
> *A. That first part? No, sir.*
> *Q. That was dictated simply from your mind?*
> *A. Yes, sir.*
> *Q. And taken directly by Mitchell on the typewriter.*
> *A. Yes, sir.*
> *Q. Mr. McCarthy, had he approved the wording?*
> *A. Yes, sir.*
> *Q. So that Sherman had nothing to say about that first paragraph, did he?*
> *A. No, sir.*
> *Q. Now, without taking too much time, did you dictate any of the second paragraph?*

*A. There was some of it there that I put on. Where it ended I am not sure.
Lieutenant McCarthy went on from there…*

To strengthen his argument that the signed confession did not accurately reflect Newell's statements, Buckley put his client on the stand as a rebuttal witness.

"We had gone about ten or twelve feet, and it was very difficult swimming," Newell said. "In the excitement of the moment I had forgotten to take off my shoes and pants…I was tired out at that time and I didn't think I could make it back to the canoe unless I took off my shoes…so I doubled up, untied my left shoestring, and kicked that shoe off. During this time we were struggling in the water, and from self-preservation and lack of manhood, or whatever it may be—I was swallowing water and my wife was the same—and I twisted away from my wife while I was attempting to get the second shoe off, and she went down." Buckley continued:

Q. And was this the story that you told in the [barracks]?
A. That is what I told them.
Q. Was there anything said…about your tipping the canoe over purposely?
A. There was not.
…
Q. At any time were you asked to write out a confession yourself?
A. I was not.
…
Q. After the confession was dictated, what did they do?
A. They gave me copies and asked me to sign them.
Q. Did you read them?
A. I did not.
Q. Did they ask you to read them?
A. I don't believe so.
Q. You signed them?
A. I did.
Q. Why did you sign them, Mr. Sherman?
*A. As a matter of fact, I was afraid they would take up more questioning
or more interrogation or more talk, I was dazed at what I had been through.*
Q. Had you slept any the night before?
A. No.

In his cross-examination, Hoban attempted to undermine Newell's credibility. Newell had initially told investigators that when he and Alice emerged from the water, they were eight or ten feet away from the canoe. Later that day, after a lunch break, he had admitted that they had come up right next to the canoe and clung to it for a while before deciding to swim for shore. Hoban asked:

> Q. *This is true, isn't it, that you did make statements upstairs before you went down to lunch, that is right, isn't it?*
> A. *Yes.*
> Q. *Then you went down to lunch and you changed that statement?*
> A. *Yes.*
> Q. *You didn't tell them the truth the first time they asked you, did you?*
> A. *No.*
> Q. *That is all.*

In his opening remarks for the defense, Buckley said of Newell's confession, "there isn't one word in that whole statement that is typed there that is his...they [the arresting officers] made it up, one suggesting to the other." Then he put his client in the stand in his own defense. Newell insisted that the police had fabricated the confession. Hoban opened his cross-examination by challenging that assertion. He handed Newell a copy of the confession:

> Q. *You say that that entire statement was dictated by Officers McCarthy and Sheehan to Mitchell?*
> A. *Yes, sir.*
> Q. *And that you did not furnish any information while it was being dictated?*
> A. *When they referred to me about distance and direction.*
> Q. *Well, let us take the statement up, if you will. Hold it in your hand. Shall I read the first paragraph?*

He led Newell through the statement line by line, stopping repeatedly to ask, "That is correct, isn't it?" and "That it is the truth, isn't it?" and "They had no way of knowing that themselves except you told them?" Newell eventually conceded that everything in the statement was true except for four items, most importantly the line that read, "At this point I deliberately tipped the canoe over with the intention of drowning my wife."

Q. You say you did not say that?
A. No, sir.

Newell also took exception to the statement, "She sank immediately after I pushed her away":

Q. That is true, too, isn't it?
A. I did not push her away.
Q. You did not push her away?
A. No.
Q. But she sank immediately after you broke the hold?
A. Yes.
Q. That you did intentionally.
A. Yes, sir, to save my life.
Q. I did not ask you why you did it.
A. No, you didn't.

When the reading of the confession was finished, Newell again asserted that he had signed it under duress: "I was in a dazed condition, I hardly heard a thing they dictated to the typist. I had not slept the night before. I had been under a four-hour grilling." Hoban attacked:

Q. You were all in?
A. Certainly.
Q. How many sheets of paper did Mitchell put in the typewriter?
A. Four.
Q. How many carbons did he put in?
A. Three.
Q. Where did he sit?
A. With his back towards the door and to the hall.
Q. Was the door locked?
A. It was.
Q. Where did you sit?
A. I sat in front of the desk that Mitchell sat at.
Q. There was a desk in the room?
A. Well, a table.
Q. How many people in the room?
A. There were four.
Q. Where did Thompson sit?

A. He sat on the couch.

Q. Where did you sit, in reference to Mitchell?

A. Sat in front of him.

Q. The screen door was closed on the balcony?

A. Yes, sir.

Q. The other door open?

A. When?

Q. Then. I don't mean the door into the room, I mean the door onto the balcony.

A. Yes.

Q. Do you remember all of those details?

A. Yes.

…

Q. You can read, can't you?

A. Certainly I can read.

…

Q. Here you were in this room with four officers with a signed statement, with a statement you knew they were preparing for some purpose, didn't you?

A. Certainly.

Q. What did you think the purpose was?

A. They prepared that statement to implicate me or to show that I had intentionally drowned my wife.

Q. You knew that that was their intention…And you deliberately lent yourself to the execution of that design?

A. Not deliberately.

Q. But you did it, didn't you?

A. Eventually.

Q. Well, you did?

A. I did it.

…

Q. When did they accuse you?

A. Right after I finished telling my story to them.

Q. What did they say?

A. Sheehan said—

Q. And who said it?

A. Mr. Sheehan. "We have studied human nature, we can tell by the looks of you that you are a murderer, just the sort of a man that would do a thing like this."

Q. You say that is an accusation of criminal conduct against you?

A. Certainly. I should think so.
Q. And it was after that that you signed this confession which is an admission?
A. Yes.

Having argued the point that Newell had not been too "dazed" to understand the confession he signed, Hoban focused on motive: his relationship with Esther Magill. Newell claimed to have ended the relationship on April 26, but the prosecutor challenged that story:

Q. Two days before Mrs. Sherman died you gave Magill fifteen dollars and told her she might use the other thirty dollars she had which belonged to you?
A. Yes. Dollars are not affection.
Q. What is that?
A. Dollars are not affection.
Q. What is affection as you understand it?
A. It is the interpretation of the feelings you have for someone.
Q. Well, does the hugging and kissing you indulged in with Magill in the back seat of your automobile indicate affection for her from you?
A. Yes, and it was reciprocated.
Q. Undoubtedly.

In an attempt to bolster his client's credibility, Buckley called a number of character witnesses. Newell's mother was among them. She was asked about the state of her son's marriage. "At first they were very congenial and greatly in love," she replied, "but this last winter there was, of course, there was a little friction. They weren't quite so, but then, after this birthday… conditions were much improved. [They went out together] as often as they could." Hoban kept his cross-examination brief:

Q. Mrs. Sherman—
A. Yes, sir.
Q. Alice was a faithful wife and a good mother?
A. Alice was a good girl.
Q. A good girl. Thank you very much. That's all.

THE ULTIMATE PRICE

Court was adjourned until Monday morning, when attorneys made their closing arguments. Buckley again claimed that the confession was false:

> [A] *fabrication to get this case before the public, to make of it again an "American Tragedy," and if not why was the confession given to a newspaper, given to a newspaper on Monday and blazoned across the countryside in every issue of every paper...[if not] for McCarthy['s] own personal use, his own gain, his own aggrandizement, for himself and for the officers.*

He then reminded jurors of the witnesses who had testified to Newell's good moral character: "Men of good character, truthful men, are law-abiding."

Hoban worked to provoke a sense of moral outrage, describing Alice as a "good and lovely girl" who died because of Newell's lust for Esther Magill. He again questioned Newell's account of the drowning, suggesting that Alice screamed for help *before* she fell from the boat:

> [H]*e began to rock the boat, and she knew that the doom that was awaiting her was upon her, and she set up that horrible cry in the night, that made the souls of men go cold, and uttered them with great rapidity before she was in the water, because if she went in the water she went down, she couldn't scream with her lungs and her throat full of water, all her screaming was done before the tipping of the canoe...*
>
> *He saved himself, he got the canoe under his arm and paddled it upside down, a canoe sucking air in the vacuum between the water and the canoe, a hundred feet to the shore. He could have lugged Alice Sherman in there. He admits he twisted away from her, he lost his manhood. There is enough evidence in this case, without the confession for you to convict this man of murder in the first degree.*

With closing arguments concluded, Newell was allowed to make an unsworn statement to the jury. He rose and gazed at the twelve strangers who held his fate in their hands. What thoughts, what memories raced through his mind in that desperate moment? His youthful love of Alice, his intoxicating infatuation with Esther Magill, the Boy Scout troop of which he was so proud, his music, his parents, his tiny children or the neighbors he had known since childhood? The whole tattered saga of his short life? Whatever

his thoughts, he faced the jurors and solemnly declared, "Gentlemen, as God is my witness, the tipping of that canoe was accidental. I have committed no crime." With that, he sat down.

The jury retired for deliberations at 4:40 p.m. After nine hours, at 1:50 a.m. on Tuesday, October 1, 1935, the jurors returned a verdict of guilty of murder in the first degree.

Newell's defense team immediately filed an appeal, arguing that the confession had been coerced and his Fifth Amendment rights violated. The Massachusetts Supreme Court denied the appeal on May 27, 1936. On May 29, Newell faced Judge Hammond again, where he was sentenced to the "punishment of death by the passage of a current of electricity through your body within the week beginning Sunday, the second day of August, in the year of our Lord one thousand, nine hundred and thirty-six."

His parents pleaded unsuccessfully with Governor James M. Curley to commute their son's sentence to life in prison. His lawyers filed a motion for a stay of execution with the state Supreme Court. This was denied by Chief Justice Arthur P. Rugg on August 3, the day before execution was set to take place. Upon receiving the denial, his attorneys sped to the Chatham summer home of Justice Louis D. Brandeis of the United States Supreme Court, where they argued that their client's Constitutional rights had been violated. After an hour's consideration, Brandeis said, "This is wholly a matter for the state courts."

There was no reprieve. On August 4, 1936, at 12:30 a.m., Newell P. Sherman "walked quietly to his death in the electric chair" at Charlestown Prison. His parents were home in their Sutton farmhouse. Esther Magill was in seclusion with relatives. There is no record of where Alice's parents spent the night. It took him eight minutes to die.

And so ended a story of trust and betrayal, of love and lust, of a young mother lost, a father ruined, two children orphaned and two families bereft. A story, in truth, an American tragedy.

REFERENCES

Introduction

Adams, Charles J. "Little Known Spots in Worcester County. No. 1— The Scene of the First Murder." From the Collection of the Worcester Historical Society.

Woolner, Frank M. "No Coddling of Criminals in Early Worcester." From the Collection of the Worcester Historical Society.

Chapter 1. From Slavery to the Gallows

Toby, Arthur. "The Life and Dying Speech of Arthur, a Negro Man." From the Collection of the American Antiquarian Society.

Chapter 2. Fatal Aversion

Chandler, Peleg W. *American Criminal Trials*. Vol. 2. Boston: T.H. Carter, 1844. http://www.archive.org/details/americancriminal02chaniala.

Daley, Bill. "Timothy Ruggles (1711–1795). The Rise and Fall of a Massachusetts Loyalist." Sandwich History, December 2008. http://sandwichhistory.org/wp-content/uploads/2011/05/Timothy-Ruggles1.pdf.

Green, Samuel Swett. "The Case of Bathsheba Spooner: Remarks Made at the Annual Meeting of the American Antiquarian Society held in Worcester, October 22, 1888." American Antiquarian Society. http://www.americanantiquarian.org/proceedings/48055767.pdf.

Temple, J.H., and Charles Adams. *History of North Brookfield, Massachusetts, Preceded by an Account of Old Quabaug, Indian and English Occupation, 1647–1676, Brookfield Records, 1686–1783, with a Genealogical Register.* Town of North Brookfield, 1887. Internet Archive. https://archive.org/details/historyofnorthbr87temp.

Chapter 3. A Gambler's Demise

Sawyer, Herbert M. *History of the Department of Police Service of Worcester, Mass., from 1674 to 1900.* Worcester, MA: Worcester Police Relief Association, 1900.

Worcester Evening Gazette. "Another Shocking Murder!" February 29, 1868.

———. "Last Night on Earth." September 26, 1868.

Chapter 4. Gentleman George's Last Hurrah

New York Times. "Ellwood Surrendered. He Jokes About His Burglarious Jobs and Appears Happy." September 18, 1891. http://query.nytimes.com/mem/archive-free.

Sawyer, Herbert M. *History of the Department of Police Service of Worcester, Mass., from 1674 to 1900.* Worcester, MA: Worcester Police Relief Association, 1900.

Worcester Telegram. "Is He the Masked Burglar?" September 11, 1891.

References

Chapter 5. Axe Murderer on the Loose

Idaho Daily Statesman. "Believed to be Dunham." January 15, 1898. America's Historical Newspapers. http://infoweb.newsbank.com.

New Haven Evening Register. "Not the Brookfield Murderer. Man Held at North Stonington under Suspicion Doesn't Fit the Description." January 21, 1898. http://infoweb.newsbank.com.

————. "Three Dead in Their Home." January 10, 1898. America's Historical Newspapers. http://infoweb.newsbank.com.

New York Times. "An Entire Family Murdered." January 11, 1898. http://query.nytimes.com/mem/archivefree/pdf.

Chapter 6. Triple Suicide or Sinister Plot?

Fiske, Jeffrey H. *History of Spencer, Massachusetts—1875–1975.* Spencer, MA: Spencer Historical Commission, 1990.

Jones-D'Agostino, Steven. "The Greatest Mystery Ever Told." *Worcester Magazine* (October 30, 1985).

Mudd, Tom. "Getting at the Truth Behind the Hammond Tragedy." *New Leader*, October 29, 1987.

Spencer Sun. "Causes Two Deaths. Suicide of Henry Hammond Causes Second Tragedy. Mrs. W.H. Prouty Takes Her Own Life on Following Day." January 14, 1899.

————. "Doubly Sad. Suicide of Henry Hammond a Shock to the Community." January 7, 1899.

Worcester Telegram. "Too Timid to Marry, Lad Shoots Himself!" January 7, 1899.

REFERENCES

CHAPTER 7. MAJOR LEAGUE NIGHTMARE

McKenna, Brian. "Marty Bergen." Society for American Baseball Research. http://sabr.org/bioproj/person/c19ac6cc.

Nack, William, and Mike Donovan. "Collision at Home: A Century Ago the Best Catcher in Baseball, Boston's Martin Bergen, Waged a Losing Battle Against Mental Illness—a Violent Struggle in Which He Was Not the Only Casualty." *Sports Illustrated* (June 4, 2001). http://www.si.com/vault/2001/06/04/304662/collision-at-home.

New York Times. "Kills His Entire Family." January 20, 1900. http://query.nytimes.com.

CHAPTER 8. SLAUGHTER OF INNOCENTS

Barre Gazette. "The Truth of the Coldbrook Tragedy." April 19, 1901.

The Transcript. "Mrs. Naramore Released." December 4, 1906.

———. "An Unnatural and Shocking Deed at Coldbrook." March 22, 1901.

CHAPTER 9. "AMERICAN TRAGEDY" ON LAKE SINGLETARY

Commonwealth v. Newell P. Sherman, 1935. Trial transcript. Private collection.

Lewiston Evening Journal. "Sherman Will Be Tried on September 3." July 23, 1935.

Pittsburg Press. "'Tragedy' Jury Decrees Death." October 1, 1935.

Reading Eagle. "'American Tragedy' Slayer Is Executed." August 4, 1936.

Schenectady Gazette. "Choir Singer's Murder Trial Begins Today." September 21, 1935.

ABOUT THE AUTHOR

Rachel Faugno is a freelance writer and teaches English at Quinsigamond Community College in Worcester, Massachusetts.